M. C. ESCHER

29 MASTER PRINTS

INTRODUCTION BY M. C. ESCHER

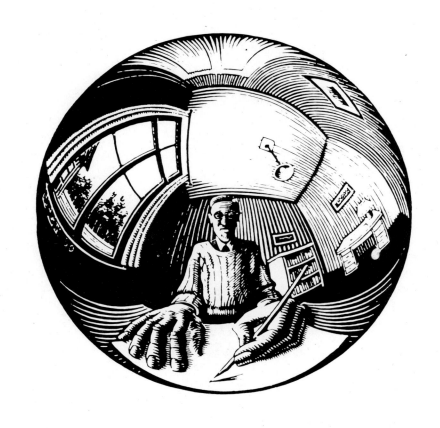

HARRY N. ABRAMS, INC., PUBLISHERS, NEW YORK

Cover: **RIND**
May 1955. Catalogue number 401
Wood engraving and woodcut in black, brown, blue-gray,
and gray, printed from four blocks
345 x 235 (13⅝ x 9¼")
This print depicts Escher's wife, Jetta. It also exists
in other color combinations.

A spiraling ribbon, like an orange peel, portrays a fragmentary woman's head. It floats through space as a hollow sculpture. The illusion of depth is accentuated by means of a cloud cover, receding toward an invisible horizon.

A novel of H. G. Wells, entitled *The Invisible Man*, induced me to make this print. The hero of this fantastic story has prepared a mysterious chemical liquid. When he drinks it, his body gets perfectly translucent. But this invisibility being rather inconvenient, he wants to get visible again and swathes his face with a bandage. My picture presents a similar situation. At the same time it gave me occasion to draw a recognizable portrait, externally as well as internally. M. C. E.

Editor: Darlene Geis
Designer: Samuel N. Antupit

The introduction and commentaries by M. C. Escher were taken from *M. C. Escher: His Life and Complete Graphic Work, The World of M. C. Escher*, and some heretofore unpublished lecture notes of the artist kindly supplied by Meulenhoff & Co., bv, Amsterdam. Commentaries by J. L. Locher, C. H. A. Broos, H. S. M. Coxeter, and Bruno Ernst were taken from the aforementioned works with the kind permission of Meulenhoff & Co.

Text © 1971, 1981 by Meulenhoff & Co., bv, Amsterdam
Illustrations © 1981 M. C. Escher Heirs, c/o Beeldrecht, Amsterdam
Published in 1983 by Harry N. Abrams, Incorporated, New York

Library of Congress Cataloging in Publication Data
Escher, M. C. (Maurits Cornelis), 1898–1971.
 M. C. Escher, 29 master prints.
 1. Escher, M. C. (Maurits Cornelis), 1898–1971—
Catalogs. I. Title. II. Title: M. C. Escher, twenty-nine master prints.
NE670.E75A4 1983 769.92′4 82-13904
ISBN 0-8109-2268-1 (pbk.)

Printed and bound in Japan

CONTENTS

ON BEING A GRAPHIC ARTIST

I t is human nature to want to exchange ideas, and I believe that, at bottom, every artist wants no more than to tell the world what he has to say. I have sometimes heard painters say that they work "for themselves," but I think they would soon have painted their fill if they lived on a desert island. The primary purpose of all art forms, whether music, literature, or the visual arts, is to say something to the outside world; in other words, to make a personal thought, a striking idea, an inner emotion perceptible to other people's senses in such a way that there is no uncertainty about the maker's intentions. The artist's ideal is to produce a crystal-clear reflection of his own self. Thus an artist's talent is not only determined by the quality of the thoughts he wishes to convey—for anyone can have the most beautiful, the most moving images in his head—but also by his ability to express them in such a way that they get through to other people, undistorted. The result of the struggle between the thought and the ability to express it, between dream and reality, is seldom more than a compromise or an approximation. Thus there is little chance that we will succeed in getting through to a large audience, and on the whole we are quite satisfied if we are understood and appreciated by a small number of sensitive, receptive people....

There is a noticeable difference between two groups of people that can be distinguished and compared because they have ideas and opinions with an apparently different orientation. I could not think of two names to characterize and distinguish them. The terms "rationalist" and "sentimentalist," for example, do not express what I mean. For want of anything better I have called them "feeling people" and "thinking people," but their real character will become clear only if I describe them.

By "feeling people" I mean those who, amid everything surrounding them, are most interested in the relationship between themselves and others, and in relationships between people in general. Admittedly they are aware of phenomena in the outside world that are not directly related to people, such as nature, matter, and space, but all that does not mean very much to them. They consider it to be of secondary importance and regard it as a stage, a complex of attributes whose purpose is to act as a backdrop for people. On the other hand they are greatly fascinated by all the problems that face man in society. I call them "feeling people" because I believe that the many ideas that interest them, such as society, the state,

religion, justice, trade, and usually art, too, are in the first place related to the feeling relationships between people.

Most artists belong to this group. This is clear from the preference they have had since time immemorial for depicting the human countenance and the human form; they are fascinated by specifically human qualities, both physical and spiritual. And even if they do not depict man himself, even when a poet is describing a landscape or a painter is doing a still life, they almost always approach their subjects from their interest in man.

It may seem paradoxical to say that there are similarities between a poetical and a commercial mind, but it is a fact that both a poet and a businessman are constantly dealing with problems that are directly related to people and for which sensitivity is of prime importance. The businesslike mind is sometimes described as being cold, sober, calculating, hard; but perhaps these are simply qualities that are necessary for dealing with people if one wants to achieve anything. One is always concerned with the mysterious, incalculable, dark, hidden aspects for which there is no easy formula, but which form essentially the same human element as that which inspires the poet.

Then there is the other group, which I have rather inadequately described as "thinking people." In this group I include people who consider that they can attribute a specific significance, independent of mankind, to nonhuman natural phenomena, to the earth on which they live and the rest of the universe around it. This group understands the language of matter, space, and universe. They are receptive toward this outside world; they accept it as something that exists objectively, separate from man, which they can not only see but can also observe closely, study, and even attempt to understand, bit by bit. In doing this they are able to forget themselves to a greater extent than the feeling person usually can.

When someone forgets himself, this by no means makes him altruistic; when a thinking person forgets himself, he immediately also forgets his fellowman, he loses himself and his humanity by becoming engrossed in his subject. Thus he is in a sense more contemplative than a feeling person. Anyone who is profoundly concerned with material things in general, and whose work does not require the involvement of other people, belongs to this group. Factory workers or carpenters may belong to it just as

much as chemists or astronomers. They are people for whom the world is so real and tangible that they generally do not take into account how subjective everything is nevertheless. For as far as I know, there is no proof whatever of the existence of an objective reality apart from our senses, and I do not see why we should accept the outside world as such solely by virtue of our senses.

These reality enthusiasts are possibly playing at hide-and-seek; at any rate they like to hide themselves, though they are not usually aware of it. They simply do it because they happen to have been born with a sense of reality, that is, with a great interest in so-called reality, and because man likes to forget himself. However, it is quite possible that subconscious factors such as a fear of the dark, incomprehensible nature of the human condition sometimes play a role, and that "thinking people" are escaping from this. Disillusion, exhaustion, impotence, and other inhibitions may have led them to seek peace and respite in dealing with matters that are less complicated and easier to grasp than the enigma of man himself.

In these descriptions I have tried to highlight the contrast between the characteristics of the two groups. I do indeed believe that there is a certain contrast between, say, people in scientific professions and people working in the arts. Often there is even mutual suspicion and irritation, and in some cases one group greatly undervalues the other.

Fortunately there is no one who actually has only feeling or only thinking properties. They intermingle like the colors of the rainbow and cannot be sharply divided. Perhaps there is even a transitional group, like the green between the yellow and the blue of the rainbow. This transitional group does not have a particular preference for thinking or feeling, but believes that one cannot do without either the one or the other. At any rate, it is unprejudiced enough to wish for a better understanding between the two parties....

It is clear that feeling and understanding are not necessarily opposites but that they complement each other. You don't have to be a physicist to experience the miracle of gravity, but with the aid of our intellect our understanding of a miracle can be enhanced. I do not know if it is true, but I imagine that there are scientists who, by following the paths of the so-called "cold" intellect—possibly without being aware of it—are plumbing the depths of a mystery rather than searching for the solution to a problem....

In my prints I try to show that we live in a beautiful and orderly world and not in a chaos without norms, as we sometimes seem to. My subjects are also often playful. I cannot help mocking all our unwavering certainties. It is, for example, great fun deliberately to confuse two and three dimensions, the plane and space, or to poke fun at gravity.

Are you sure that a floor cannot also be a ceiling? Are you absolutely certain that you go up when you walk up a staircase? Can you be definite that it is impossible to eat your cake and have it?

I ask these seemingly crazy questions first of all of myself (for I am my own first viewer) and then of others who are so good as to come and see my work. It's pleasing to realize that quite a few people enjoy this sort of playfulness and that they are not afraid to look at the relative nature of rock-hard reality.

Above all I am happy about the contact and friendship of mathematicians that resulted from it all. They have often given me new ideas, and sometimes there even is an interaction between us. How playful they can be, those learned ladies and gentlemen!

To tell you the truth, I am rather perplexed about the concept of "art." What one person considers to be "art" is often not "art" to another. "Beautiful" and "ugly" are old-fashioned concepts that are seldom applied these days; perhaps justifiably, who knows? Something repulsive, which gives you a moral hangover, and hurts your ears or eyes, may well be art. Only "kitsch" is not art— we're all agreed about that. Indeed, but what is "kitsch"? If only I knew!

This emotional valuation is too subjective and too vague for me. If I am not mistaken, the words "art" and "artist" did not exist during the Renaissance and before: there were simply architects, sculptors, and painters, practicing a trade.

Printmaking is another of these honest trades, and I consider it a privilege to be a member of the Guild of Graphic Artists. Using a gouge, engraving with a burin in an absolutely smooth block of polished wood, is not something to pride yourself on—it's simply nice work. Only as you get older it's slower and more difficult, and the chips don't fly around the workroom quite so wildly as they used to.

Thus I am a graphic artist heart and soul, though I find the term "artist" rather embarrassing.

<p align="right">M. C. Escher</p>

OTHER WORLD

January 1947. Catalogue number 348
Wood engraving and woodcut in black, reddish brown,
and green, printed from three blocks
318 x 261 (12½ x 10¼")

We are in a strange room in which up, down, left, right, front, and back can be substituted arbitrarily, depending on whether we wish to look out through one window or another. The center of the picture is always the vanishing point; it is the distance point when we look through the windows on the left and in the middle. This is also the view we should expect normally.

If we look through the window at the top and the adjacent one on the right, the same vanishing point has become the nadir; we now see the moonscape from above. The central window has suddenly turned into the floor of the room.

If we look through both windows bottom right, the vanishing point has become the zenith: we are now standing on the moon looking up at the starry sky above. The central window has also changed its function: it is now the ceiling.

In this work Escher thought of a very clever way to give the single vanishing point a triple function, while drawing three pairs of virtually identical windows in the room. Bruno Ernst

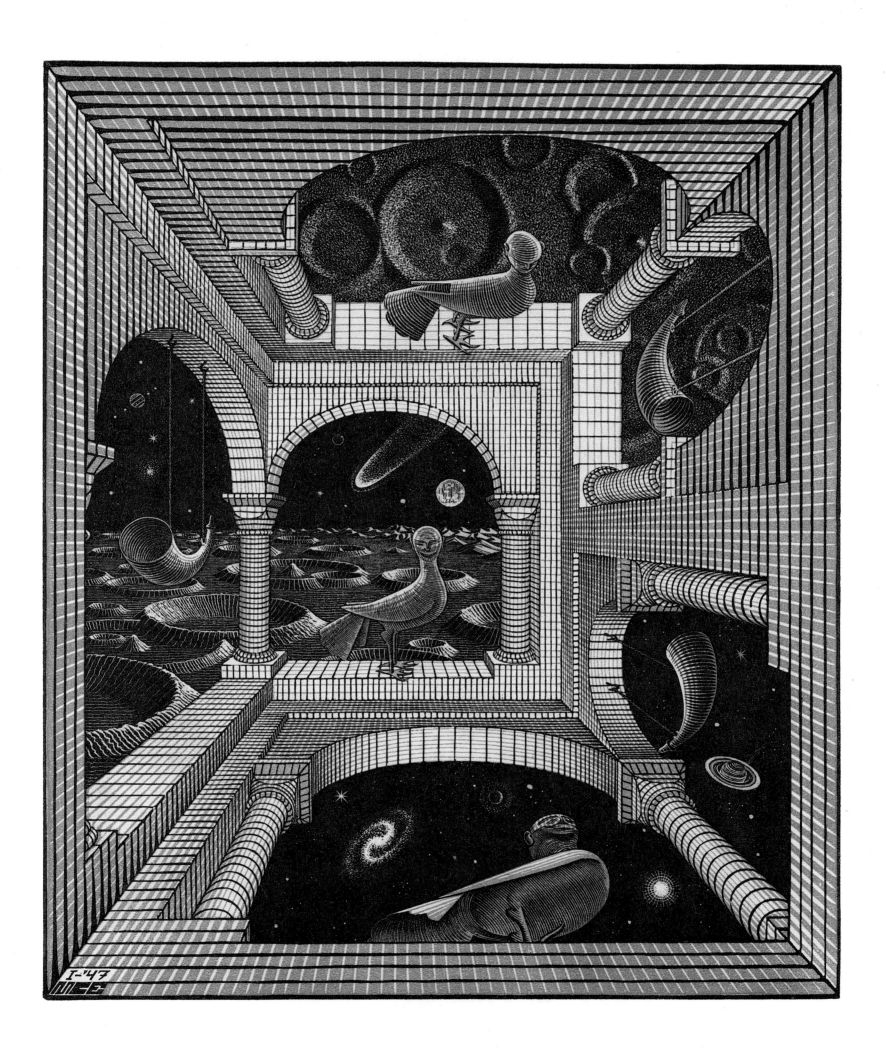

SMALLER AND SMALLER

October 1956. Catalogue number 413
Wood engraving and woodcut in black and brown,
printed from four blocks
380 x 380 (15 x 15")
There exist separate proofs of the center and the edge
of this print in one and two colors. There are also proofs
in which the center is printed in two colors and the edge
only in black.

Repetition and multiplication—two simple words. However, the whole world of the senses would collapse into chaos without these two concepts. ...In a narrower sense they lead us to the subject of..."the regular division of the plane"....In mathematical quarters, the regular division of the plane has been considered theoretically, since it forms part of crystallography....If it counts as art, why has no artist—as far as I have been able to discover—ever engaged in it?...I have never read anything about the subject by any artist, art critic, or art historian....I must therefore attempt an explanation, and offer the following:

A plane, which should be considered limitless on all sides, can be filled with or divided into similar geometric figures that border each other on all sides without leaving any "empty spaces." This can be carried on to infinity according to a limited number of systems....

The figures with which this wood engraving is constructed reduce their surface area by half constantly and radially from the edges to the center, where the limit of the infinitely many and infinitely small is reached in a single point. But this configuration, too, remains a fragment, because it can be expanded as far as one wishes by adding increasingly larger figures.

The only way to escape this fragmentary character and to set an infinity in its entirety within a logical boundary line is to use the reverse of the approach in *Smaller and Smaller.* The first, still awkward, application of this method is shown by *Circle Limit I.* The largest animal figures are now located in the center, and the limit of the infinitely many and infinitely small is reached at the circular edge. M. C. E.

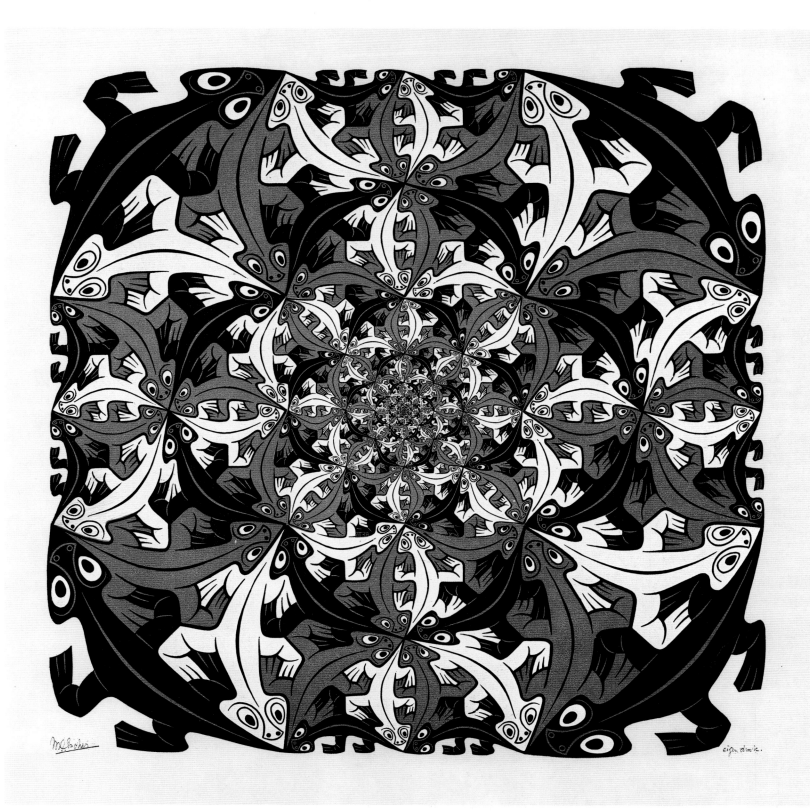

CIRCLE LIMIT III
December 1959. Catalogue number 434
Woodcut, second state, in yellow, green, blue, brown,
and black, printed from five blocks
Diameter 415 (16⅜")
There exist a large number of proofs in various colors.

I went to some trouble to explain the disk-shaped print *Smaller and Smaller (Circle Limit I)* to a number of visitors, but it's becoming increasingly clear that on the whole people are not sensitive to the beauty of this infinite world-in-an-enclosed-plane. This is particularly sad as I am working on another print, which should greatly surpass the first.... [It] is entirely based on a web of lines that are straight when they run through the center, and for the rest are all circles whose centers lie outside the disk, but increasingly close to the edge, as the circles become smaller....I...fill a plane in such a way that all the animal figures whose body axes lie in the same circle also have the same "color."...My tenacity in pursuing the study will perhaps lead to a satisfactory solution in the end.

In the colored woodcut *Circle Limit III*....There are now only series moving in one direction: all the fish of the same series have the same color and swim after each other, head to tail, along a circular course from edge to edge. The more closely they approach the center, the larger they become....

It is perhaps worthwhile to call attention to the elaborate woodcut technique of this print: it required five different woodblocks, one for the black lines and four for the colors. Each block covers a sector of ninety degrees of the whole circle, and the complete disk needed four times five, or a total of twenty printings....

No single component of all the series, which from infinitely far away rise like rockets perpendicularly from the limit and are at last lost in it, ever reaches the boundary line. Outside it, however, is the "absolute nothing." But the spherical world cannot exist without this emptiness around it, not only because "inside" presumes "outside," but also because in the "nothing" lie the strict, geometrically determined, immaterial middle points of the arcs of which the skeleton is constructed.

There is something in such laws that takes the breath away.
M. C. E.

12

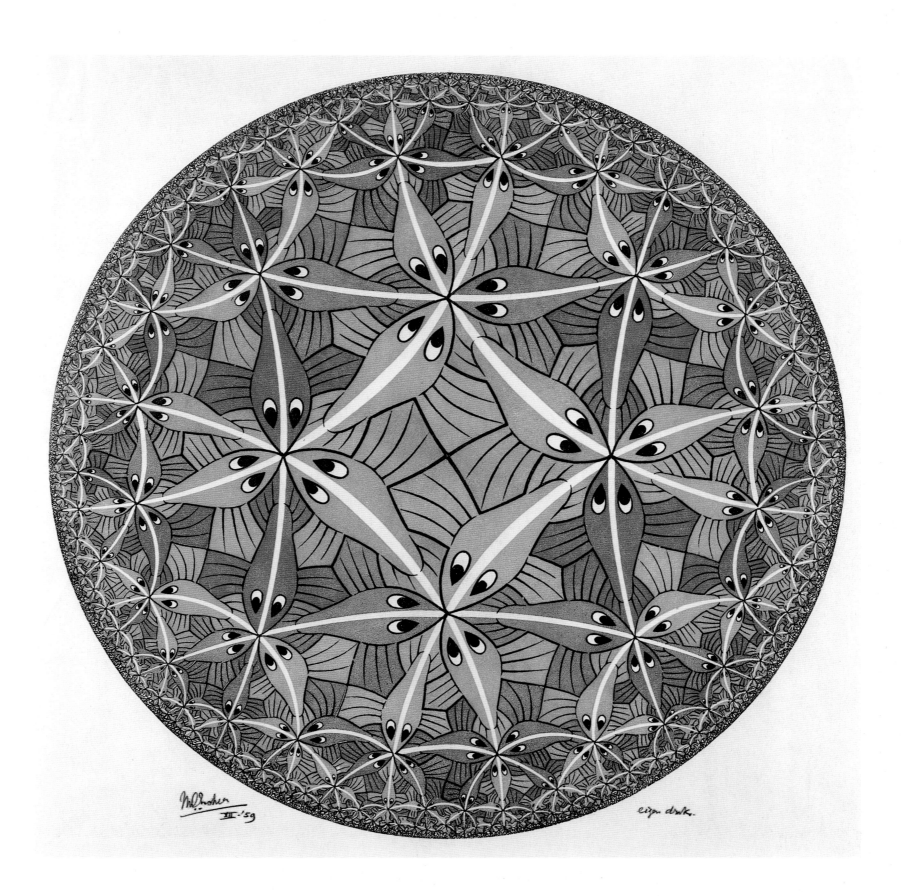

KNOTS

August 1965. Catalogue number 444
Woodcut in black, green, and brown,
printed from three blocks
430 x 320 (16⅞ x 12⅝")
There are copies with an incorrect year ('56 instead of '65). There exist proofs printed from two blocks, in black and brown, and from one block, in brown and green. There are separate prints in black and in two colors of each of the small knots (top left and top right).

D id I mention my enthusiasm about a topological knot that my *frère spirituel* Albert Flocon included in his book of engravings—though it's not well-enough done?...A thick knot-without-end, in a cable for instance, which displays the three coordinates in a most interesting way. I should definitely like to make a print of this, since I appear to see more in it than he does....

Oh dear, that knot! In the evening I sometimes feel dizzy with the effort. Can you imagine how difficult it is? I've finally arrived at a relatively definite plan: three pictures, together in one colored woodcut, with a square, a cruciform, and a circular profile of the sausage. A tour de force of perspective. Am I so stupid that it seems difficult? Perhaps I'm suffering from old age. M. C. E.

14

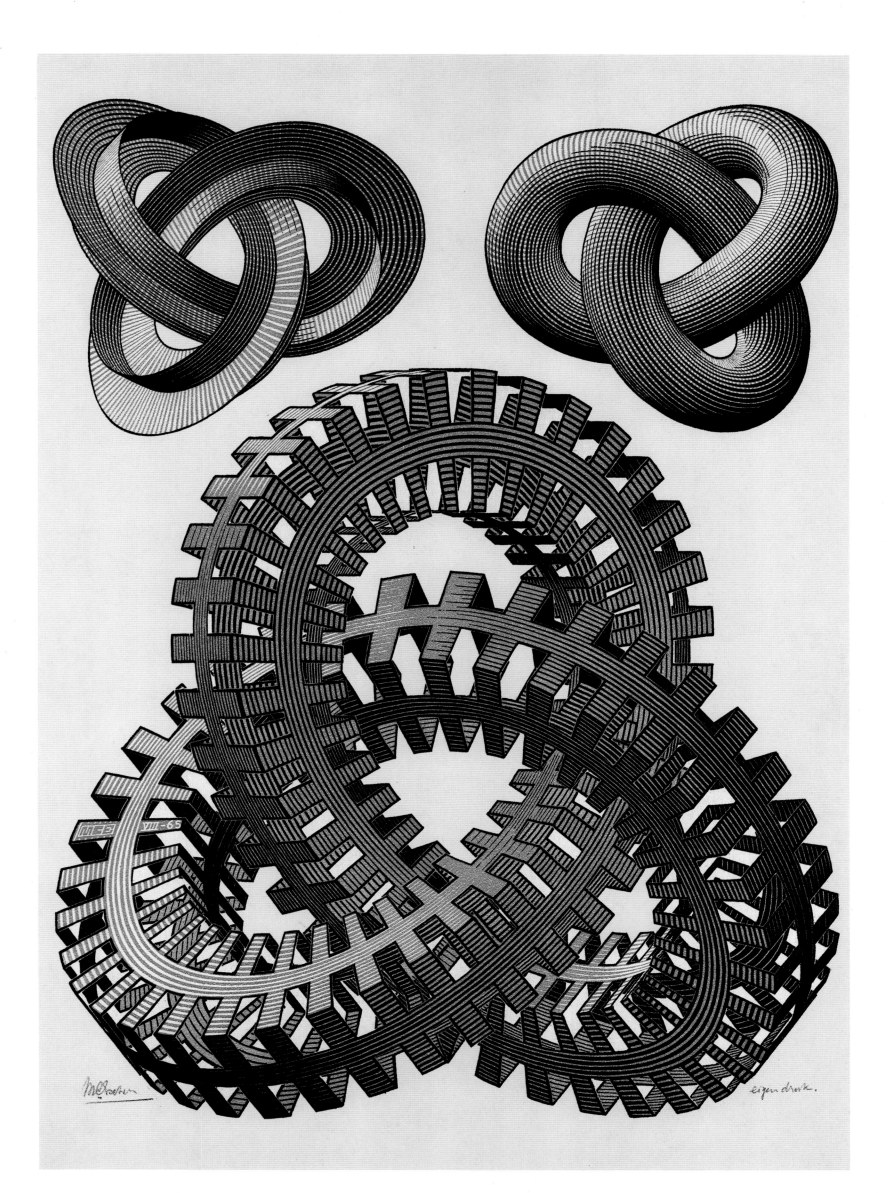

HAND WITH REFLECTING SPHERE
(SELF-PORTRAIT IN SPHERICAL MIRROR)
January 1935. Catalogue number 268
Lithograph
318 x 213 (12½ x 8⅜")
There are also copies in gold.

A child who looks into a mirror for the first time is surprised when he notices that the world behind the mirror, which looks so real, is actually "intangible"; however, he soon ceases to consider this false reality as being strange. In the course of time the surprise disappears, at least for most people. For them a mirror is merely a tool, used to help them to see themselves as others see them.

To Escher, however, the mirror image was no ordinary matter. He was particularly fascinated by the mixture of the one reality (the mirror itself and everything surrounding it) with the other reality (the reflection in the mirror)....

In the lithograph *Hand with Reflecting Sphere* of 1935, Escher is holding the sphere in his hand (which is itself reflected) so that he also has himself and his studio "in hand." Bruno Ernst

--

The picture shows [a] spherical mirror, resting on a *left* hand. But as a print is the reverse of the original drawing on stone, it was my *right* hand that you see depicted. (Being left-handed, I needed my left hand to make the drawing.) Such a globe reflection collects almost one's whole surroundings in one disk-shaped image. The whole room, four walls, the floor, and the ceiling, everything, albeit distorted, is compressed into that one small circle. Your own head, or more exactly the point between your eyes, is in the absolute center. No matter how you turn or twist yourself, you *can't* get out of that central point. You are immovably the focus, the unshakable core, of your world.

M. C. E.

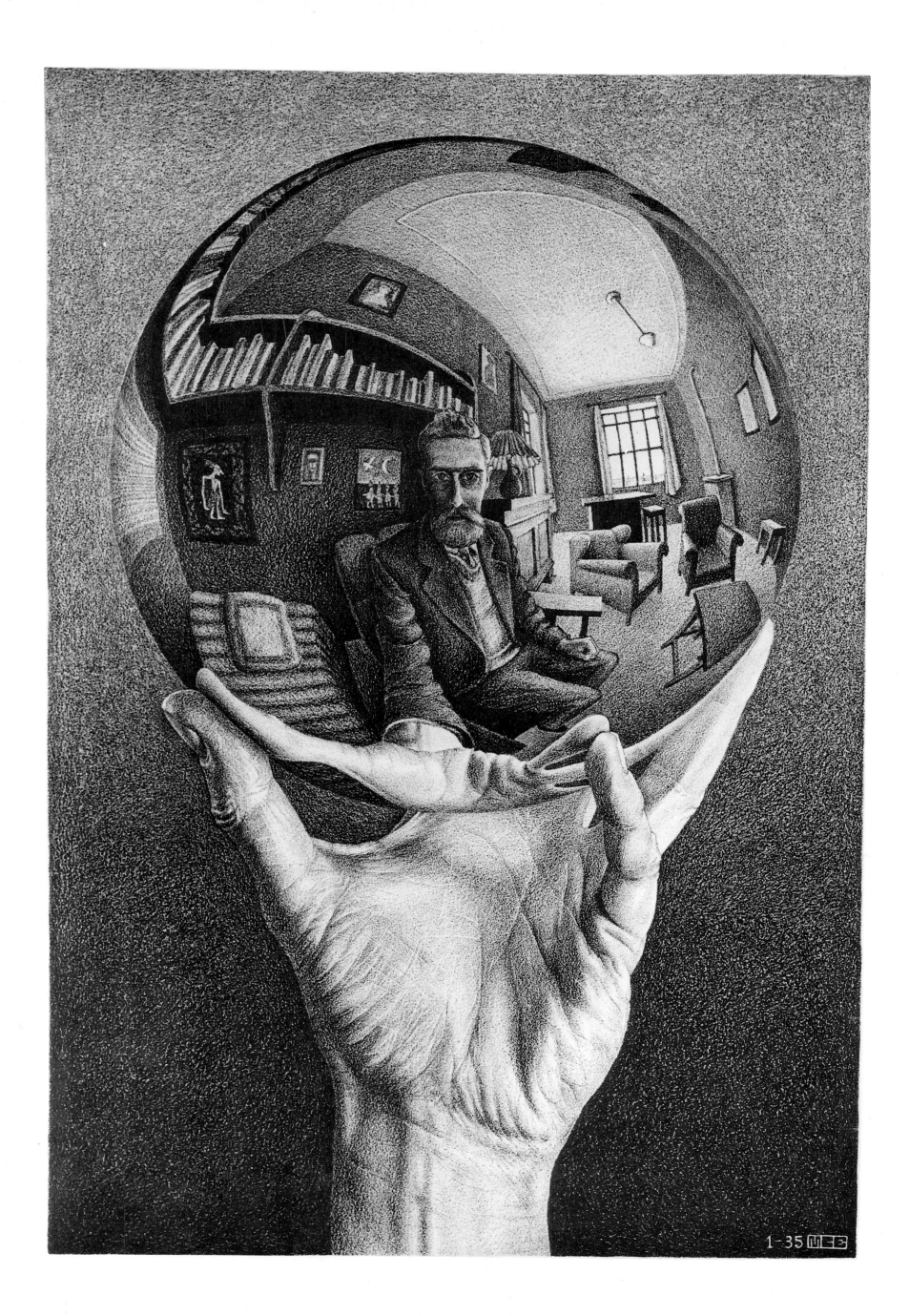

BALCONY
July 1945. Catalogue number 334
Lithograph
297 x 234 (11¾ x 9¼")
There is also an unfinished wood-engraving block
of this picture.

After finishing his studies [at the now defunct School for Architectural and Decorative Arts] Escher traveled frequently, mainly in Italy.... [Italy] had begun to fascinate him so greatly that he moved to Rome, where he lived from 1923 to 1935. While living in Rome, Escher made long journeys through the Italian countryside every spring....On these journeys he made drawings of whatever interested him, working out the best of them for prints during the winter....

After 1937 Escher became less mobile....Corresponding to the change in his way of living, there was also a change in his work after 1937. The direct impulse to make a print now almost always came not from observations of the world around him but from inventions of his own imagination—what we may call his visual thinking....

The linkage of different aspects of reality is usually taken from observations of the visible world but is also sometimes constructed from imagination. We see it here in combinations of angles of view, there in a coinciding of spatial perspective achieved by mirror effects, and again in the combination of separate observations and the double use of the contours.　　J. L. Locher

--

The print gives the illusion of a town, of house blocks with the sun shining on them. But again it's a fiction, for my paper remains flat. In a spirit of deriding my vain efforts and trying to break up the paper's flatness, I pretend to give it a blow with my fist at the back, but once again it's no good: the paper remains flat, and I have only created the illusion of an illusion.

However, the consequence of my blow is that the balcony in the middle is about four times enlarged in comparison with the bordering objects.

　　　　　　　　　　　　　　M. C. E.

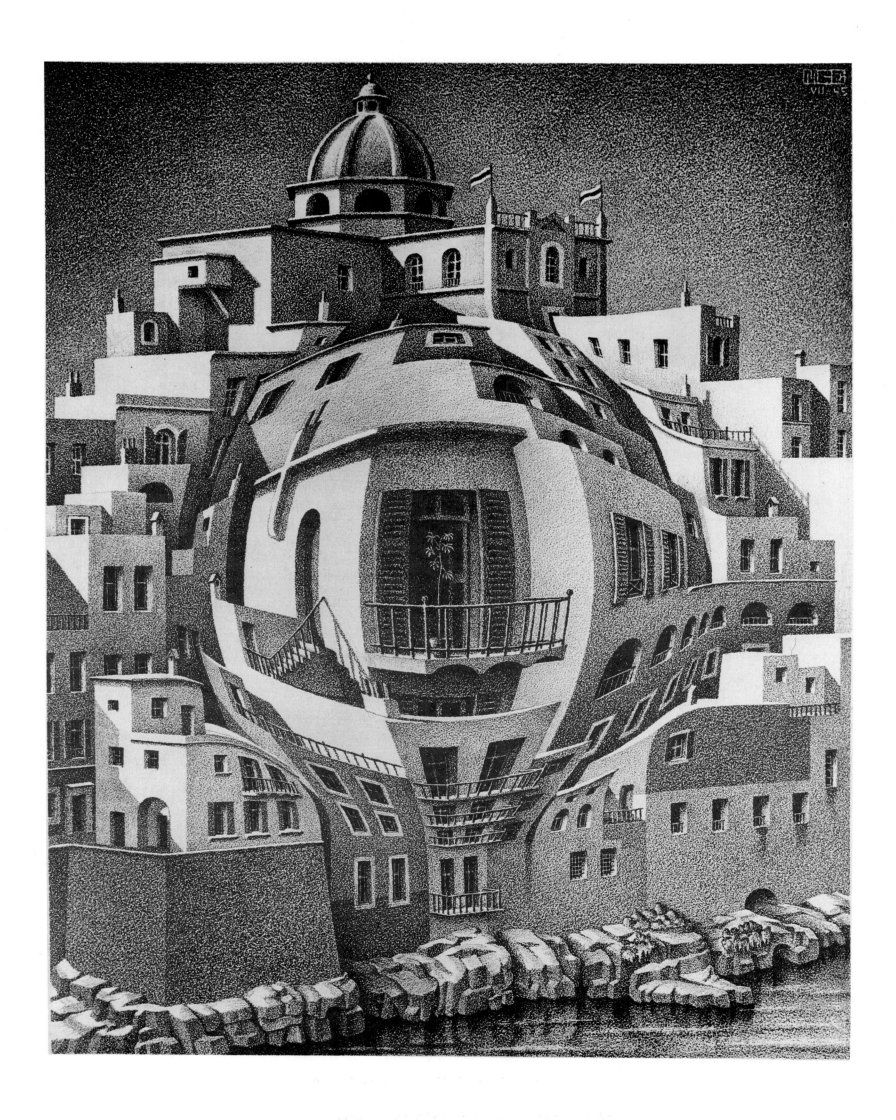

CIRCLE LIMIT IV (HEAVEN AND HELL)
July 1960. Catalogue number 436
Woodcut in black and ocher, printed from two blocks
Diameter 416 (16⅜")

Now that we have seen that a plane can be completely filled with or built up of figures, each of which depicts a recognizable object, the question arises whether they can all be an "object" at the same time. Is it possible to create a picture of recognizable figures without a background? After years of training in the composition of lines dividing equal units, I thought I could answer this question affirmatively, until I encountered some doubts through a correspondence with the ophthalmologist Dr. J. W. Wagenaar. He is better qualified than I am to judge this matter from a scientific point of view. I quote the following extract from his letter:

In my opinion you do not in fact create pictures without a background. They are compositions in which background and figure change functions alternately; there is a constant competition between them, and it is actually not even possible to go on seeing one of the elements as the figure. Irresistibly the elements initially functioning as background present themselves in a cyclical way, as figures. Your compositions do not have a visual static balance but a dynamic balance, in which, however, there is a relationship between figure and background at every stage....

Thus it seems that two units bordering on each other cannot simultaneously function as "figure" in our mind; nevertheless, a single dividing line determines the shape and character of both units, serving a double function. In this unusual and strange manner of drawing, there is understandably a complete absence of impulse and spontaneity. After a great deal of patience and deliberation, and usually a seemingly endless series of failures, a line is finally drawn, and it looks so simple that an outsider cannot imagine how difficult it was to obtain.

Instead of finishing with a square border, one can also, and perhaps better, end with a circular outline. This is no simple task but a complicated, non-Euclidean problem. The print shows angels and devils, a sort of Heaven-and-Hell combination of figures, reducing in a centrifugal direction, with alternating quaternary and ternary axes.

M. C. E.

20

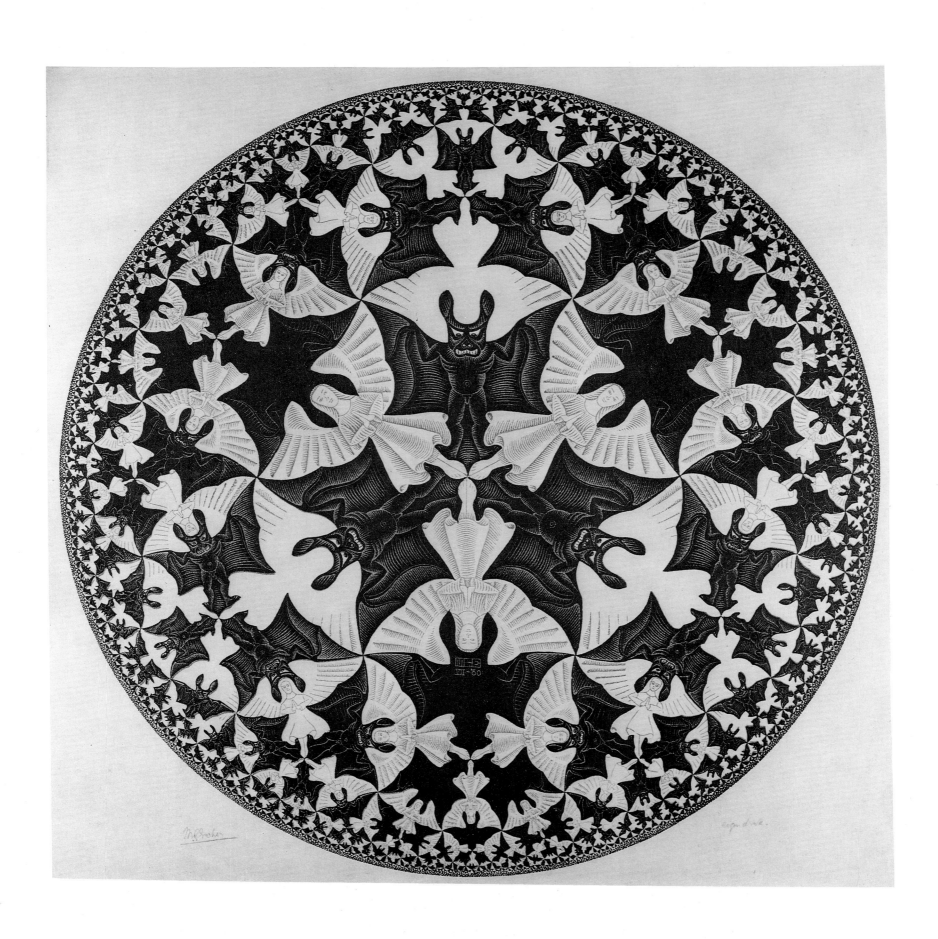

ASCENDING AND DESCENDING
March 1960. Catalogue number 435
Lithograph
355 x 285 (14 x 11¼")

I'm busy designing a new print showing a staircase that goes on endlessly ascending—or descending, if you see it that way. This would normally have to be a spiraling thing in which the top would disappear into the clouds and the bottom into Hell. Not in my version....Nevertheless, it's possible to draw it with correct perspective: each step higher (or lower) than the last one. A large number of human figures walk on it in two directions. One procession climbs wearily up *ad infinitum;* the other descends endlessly....

That staircase is a rather sad, pessimistic subject, as well as being very profound and absurd. ...Yes, yes, we climb up and up, we imagine we are ascending; every step is about ten inches high, terribly tiring—and where does it all get us? Nowhere; we don't get a step farther or higher. And descending, running down with abandon, is not possible either.

People don't like to talk about falling; they'd much rather talk about ascending. Well then.... I'm working my fingers to the bone, believing I'm ascending. How absurd it all is. Sometimes it makes me feel quite sick. M. C. E.

22

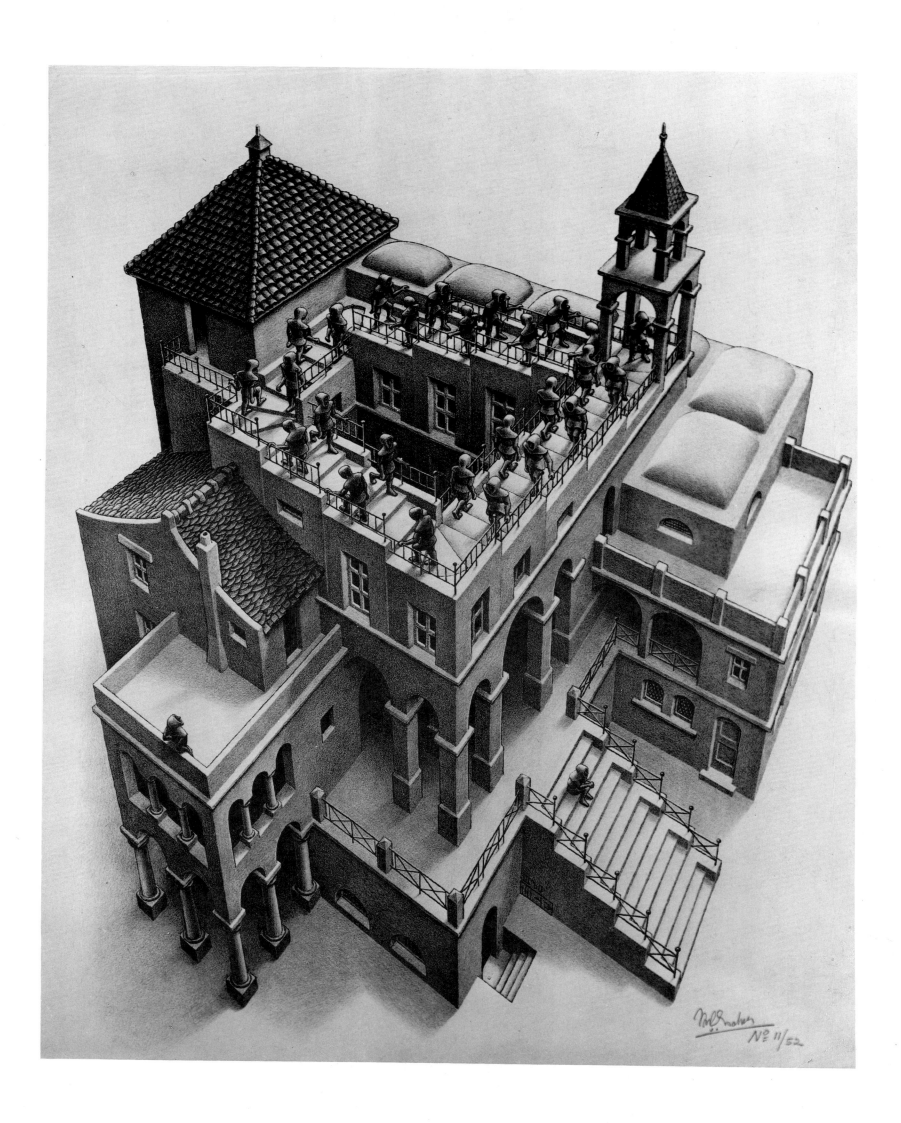

DAY AND NIGHT

February 1938. Catalogue number 303
Woodcut in black and gray, printed from two blocks
391 x 677 (15⅜ x 26⅝")

Long before I discovered in the Alhambra an affinity with the Moors in the regular division of the plane, I had recognized this interest in myself. At first I had no idea at all of the possibility of systematically building up my figures. I did not know any "ground rules" and tried, almost without knowing what I was doing, to fit together congruent shapes that I attempted to give the form of animals....

My experience has taught me that the silhouettes of birds and fish are the most gratifying shapes of all for use in the game of dividing the plane. The silhouette of a flying bird has just the necessary angularity, while the bulges and indentations in the outline are neither too pronounced nor too subtle. In addition, it has a characteristic shape, from above and below, from the front and the side....

This most fascinating aspect of the division of the plane...the dynamic equilibrium between the motifs...has led to the creation of numerous prints. It is here that the representation of opposites of all kinds arises. For is not one led naturally to a subject such as *Day and Night* by the double function of the black and the white motifs? It is night when the white, as an object, shows up against the black as a background, and day when the black figures show up against the white.

M. C. E.

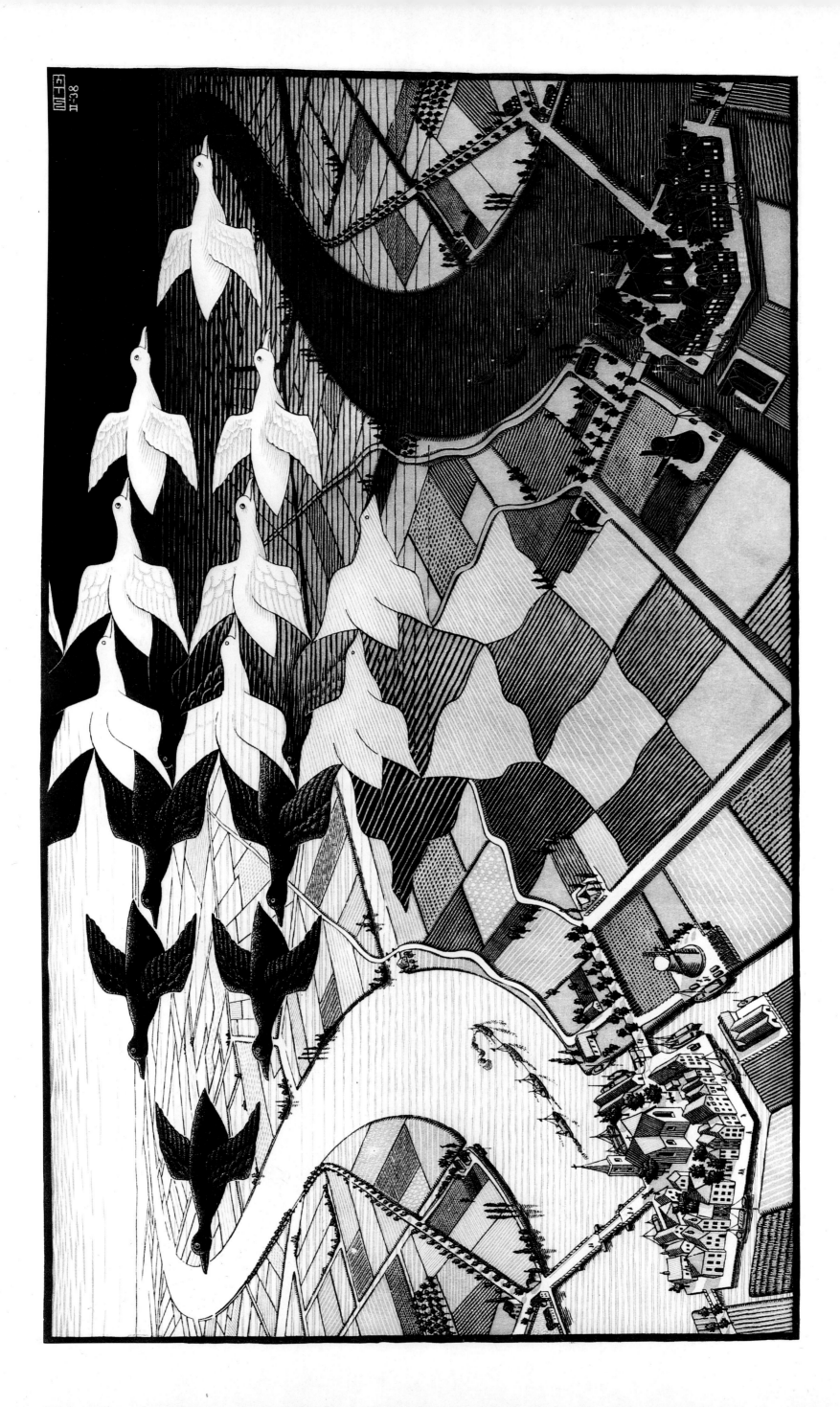

REGULAR DIVISION OF THE PLANE III
June 1957. Catalogue number 418
Woodcut in red
240 x 180 (9½ x 7⅛")

any of the brightly colored tile walls and floors of the palaces of the Alhambra in Spain show us that the Moors were masters in the art of filling a plane with similar, interlocking figures, bordering one another without gaps. Japanese artists also produced some rare examples of these curious patterns.

What a pity that the religion of the Moors forbade them to make images! It seems to me that they sometimes have been very near to the development of their elements into more significant figures than the abstract geometric shapes they formed. No Moorish artist has, as far as I know, ever dared (or didn't he hit on the idea?) to use as components concrete, recognizable figures borrowed from nature, such as fish, birds, reptiles, or human beings. This is hardly believable, for *recognizability* is so important to *me* that I never could do without it.

Another important question is color contrast. It has always been self-evident for the Moors to compose their tile planes with pieces of majolica in contrasting colors. Likewise, I have never hesitated myself to use color contrast as a means of visualizing my adjacent components of a pattern.

--

From three available principles of dividing a plane, we have to choose one. For the sake of brevity the three principles can be characterized as "sliding", "rotation", and "glide reflection"... *Regular Division of the Plane III* embodies the third principle....The figures that constitute the pattern are all similar, but the black horsemen and the white horsemen are each congruent only among themselves, that is, only the black can cover black, and white, the white, without moving off the plane. (Just as a right and left hand are not congruent, though they are similar.)...If, however—as in the case of the horsemen—motifs are repeated in mirror image, one of them has to move through the third dimension for covering to be possible. It must leave the plane and be turned upside down before being slid to cover its former reflection. This is the movement summarized in the term "glide reflection." **M. C. E.**

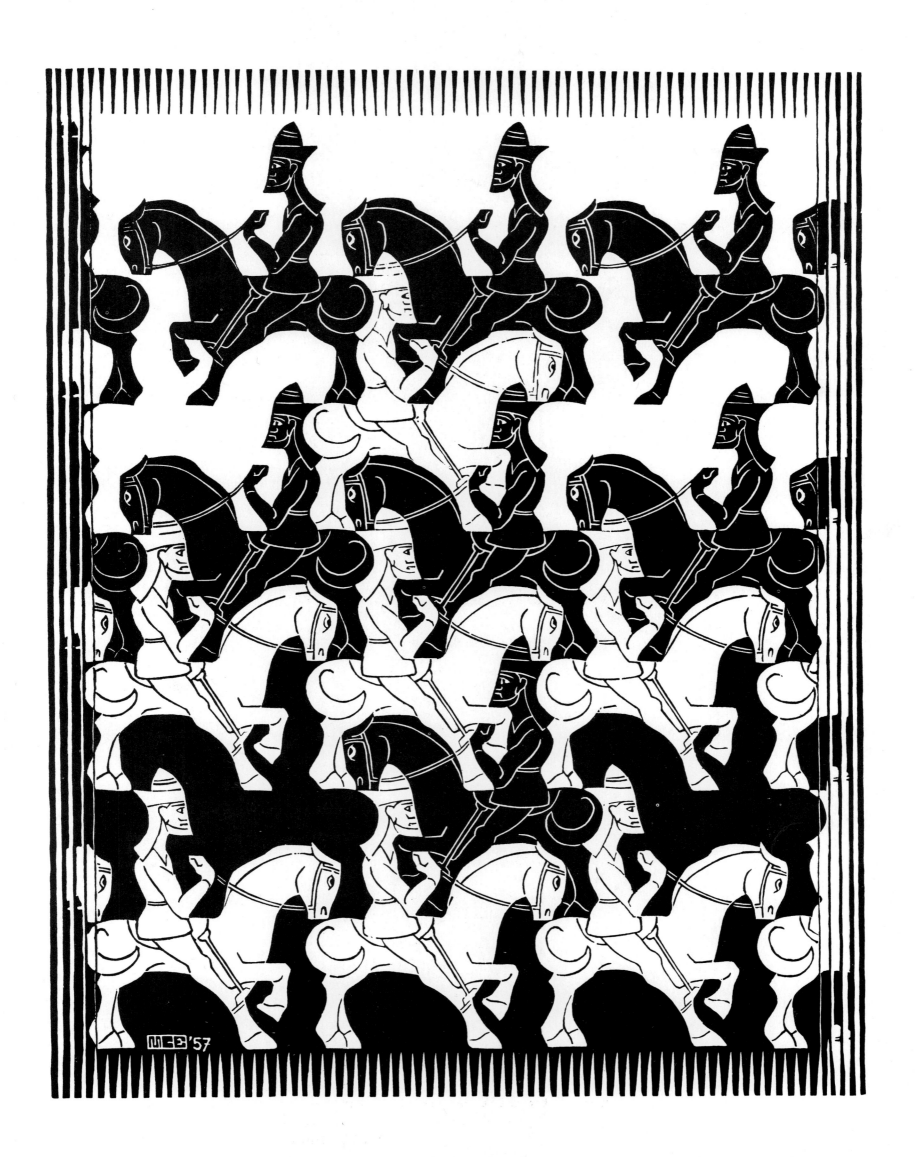

SKY AND WATER I

June 1938. Catalogue number 306
Woodcut
435 x 439 (17⅛ x 17¼")

The idea of a duality such as air and water can be expressed in a picture by starting from a plane-filling design of birds and fish; the birds are "water" for the fish, and the fish are "air" for the birds. Heaven and Hell can be symbolized by an interplay of angels and devils. There are many other possible pairs of dynamic subjects—at least in theory, for in most cases their realization meets with insuperable difficulties. M. C. E.

--

This print has been used in physics, geology, chemistry, and in psychology for the study of visual perception. In the picture a number of elements unite into a simple visual representation, but separately each forms a point of departure for the elucidation of a theory in one of these disciplines.

The basis of this print is a regular division of the plane consisting of birds and fish. We see a horizontal series of these elements—fitting into each other like the pieces of a jigsaw puzzle—in the middle, transitional portion of the print. In this central layer the pictorial elements are equal: birds and fish are alternately foreground or background, depending on whether the eye concentrates on light or dark elements. The birds take on increasing three-dimensionality in the upward direction, and the fish, in the downward direction. But as the fish progress upward and the birds downward they gradually lose their shapes to become a uniform background of sky and water, respectively.

We can think of a number of paired concepts applying to this picture: light–dark, top–bottom, flat–rounded, figure–background, interlocking pictorial elements–independent pictorial elements, geometric structure–realistic form; and, with respect to the subject of the print, birds–fish, sky–water, immobility–movement. Any scientist who uses a print to illustrate a theory selects one or more elements from the print that are analogous to components of the theory, and in this way the print becomes a model for the theory.

C. H. A. Broos

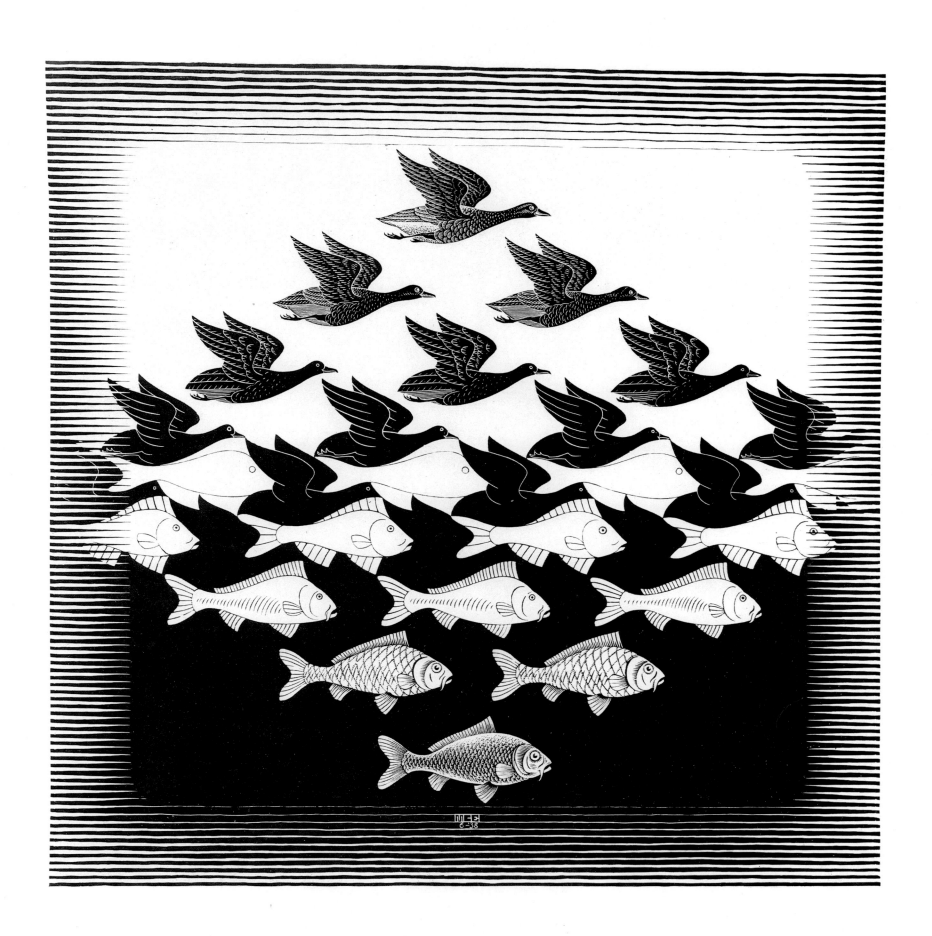

CYCLE

May 1938. Catalogue number 305
Lithograph
475 x 279 (18¾ x 11")

A jolly little man leaves his house and runs down the stairs. On the way he loses his spatial quality and arrives, flat and gray, amidst white and black fellow creatures. Each one of them simplifies into a rhomb. Three rhombs suggest a cube; the cube borders the house, and from the house once again appears the little man. And so on, and so on, in an endless circular movement. M. C. E.

Escher's copies of the Moorish mosaics in the Alhambra...made in the summer of 1936, contributed to his renewed interest in the possibility of a double use of contours. The mosaics are composed of regular repetitions of basic geometric figures that could in principle continue to infinity. They fascinated Escher because he recognized in them problems with which he had been preoccupied in 1922 and 1926 but for which no application had occurred to him at that time. The mosaics led him to take up the problem again and to carry it further....Ultimately he was interested not in an interlocking series of abstract patterns but in the linkage of recognizable figures. He tried to bring abstract patterns to life by *substituting* them with animals, plants, or people....

The movement by which [these figures] are transformed into each other...forms a closed cycle, a feature recurring in many of Escher's prints. The closed cycle fascinated him because with it something of infinity could be captured within the finite. We see closed cycles in such prints as *Reptiles, Magic Mirror, Swans,* and *Cycle.* J. L. Locher

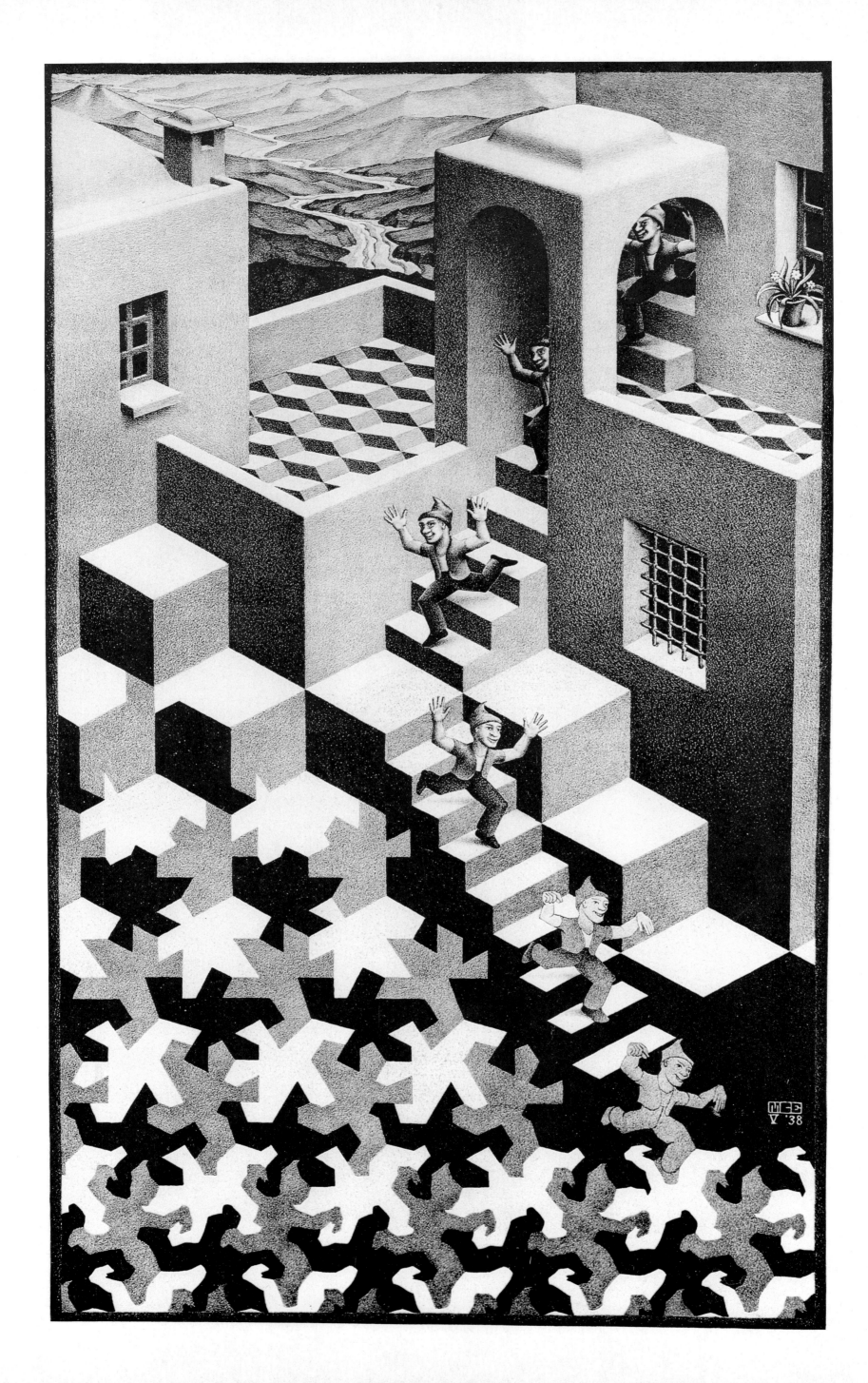

METAMORPHOSIS III

1967–68. Catalogue number 446
Woodcut, second state, in black, green, and reddish brown,
printed from thirty-three blocks on six combined sheets,
mounted on canvas; partly colored by hand
192 x 6800 (7½ x 268")
There are also copies of the first state, of the separate
parts, and proofs of the separate parts in various color
combinations. The number of blocks is based on a count
made in 1980.

It is difficult to describe the metamorphosis of the motifs...[take] the fragment...[that] shows just one metamorphosis, namely, from left to right, the transition from "insect" to "bird." First the black insect silhouettes join; at the moment when they touch, their white background has become the shape of a fish. Then figures and background change places and white fish can be seen swimming against a black background. Thus the fish function as a catalyst; their shape hardly changes but their position vis-à-vis each other does: their ranks change. When they have joined, the spaces between them have turned into birds....

Here I should like to venture still further and point out comparisons, possibly even analogies, between the regular division of the plane and music....Before I mention what I see as correspondences, I should question whether it is meaningful to compare image and sound....Music exists only as it is heard...whereas a series of pictures is static and does not have to be recreated continually once it has been made....

Despite these differences in their natures, I believe that the series of images in the division of a plane and the succession of sounds in a piece of music can be seen as if they were rungs of a single ladder, linked by intermediate rungs....That general elements such as rhythm and repetition play an important role both for the ears in music and for the eyes in the division of the plane also indicates some relationship between them....

More particularly it seems that musical canons incorporate concepts such as augmentation, diminution, retrogression, and even mirroring. These are visually indicated in the score in a way directly comparable with the figures of the regular division of a plane. M. C. E.

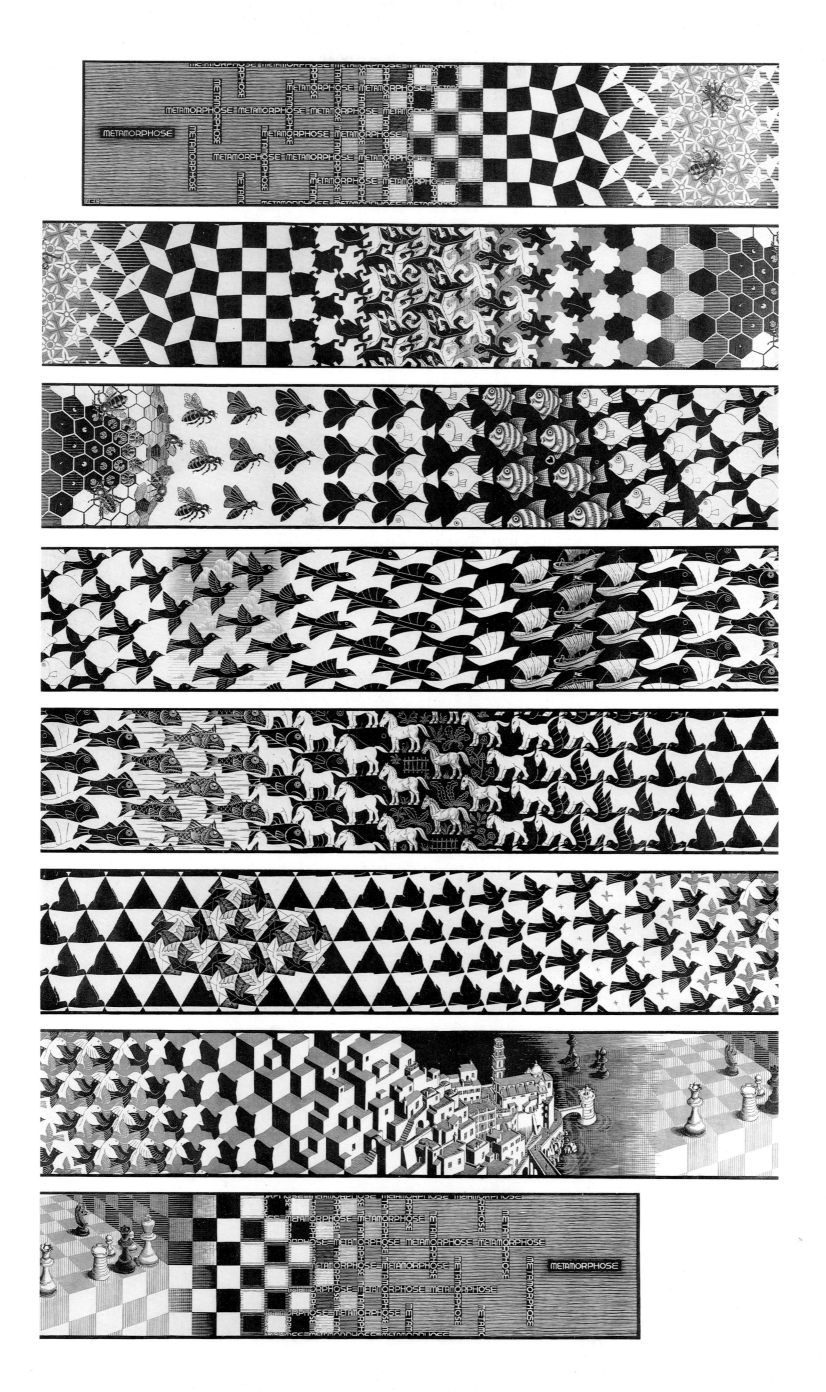

BELVEDERE
May 1958. Catalogue number 426
Lithograph
462 x 295 (8¼ x 11⅝")
The woman at bottom right comes from the lithograph
Hell, a detail of the painting The Garden of Delights
by Hieronymus Bosch. The background comes from a
1929 scratch drawing. The man with a cuboid at left is
the subject of a wood engraving made in 1958. In March
1965, Escher gave sixty copies of Belvedere to the
Ministry of Education, Arts, and Sciences for use in
schools in the Dutch West Indies.

This [print] shows a belvedere with three stories, seen against a mountainous background. On the floor in the foreground lies a piece of paper on which the edges of a cube are drawn. Small circles indicate the points where two edges intersect. Which of these two lines lies in front of the other depends upon how you look at the cube. The boy sitting on the bench holds in his hands a cuboid puzzle that is a mixture of these two possibilities: its top and its bottom are mutual contradictions. He broods over it and, with good reason, can't believe his eyes. Probably he isn't aware of the building behind him, demonstrating the same impossibility. For instance: the ladder in the center, though correctly drawn according to the rules of perspective and quite acceptable as an object, stands with its base *in*side the house, but *out*side with its top. Hence the two persons climbing on it are in an impossible relationship to each other. M. C. E.

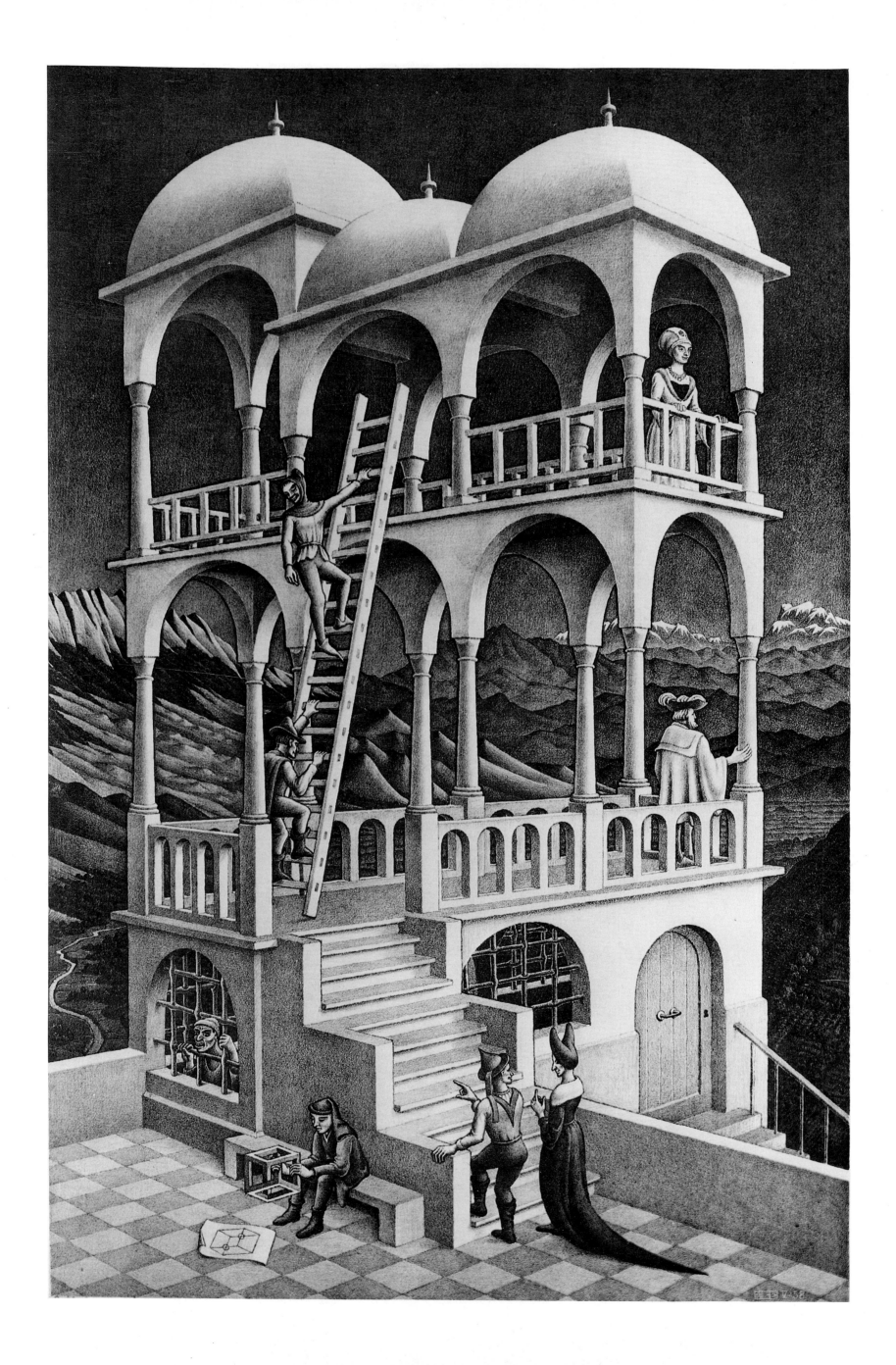

REPTILES
March 1943. Catalogue number 327
Lithograph
334 x 385 (13⅛ x 15⅛")

I n 1943 M. C. Escher drew his *Reptiles* on a lithographic stone. The print shows a notebook lying on a table, opened to a drawing consisting of a repeating pattern of small interlocking reptilian animals....The notebook is one of six still in existence, which together contain a series of drawings consisting of similar divisions of the plane, arranged by Escher according to a special system of his own....The notebooks have provided the basic material for many of Escher's prints, such as *Day and Night, Sky and Water,...Horseman, ...*and *Circle Limit IV.*

The *Reptiles* print itself illustrates one of Escher's predilections—the bringing to life of an abstract structure. By arranging a few small personal effects around the notebook—a gin glass, an ashtray, and a packet of cigarette papers—Escher suggests the presence of the artist, or rather his temporary absence, during which the drawing in the notebook, his creation, begins to have a life of its own....

In 1943 this print was known only to a small group of print collectors in the Netherlands. Now ...the situation has changed. For instance, two reproductions of this print appeared at almost the same time in two very different contexts. The basic drawing of *Reptiles* was reproduced as an illustration in an Italian chemistry textbook for secondary schools. The print also appeared on the record album cover of an American Pop group. Evidently the print contains significant material for both the chemist and the Pop-music producer. The scientist is interested in the regular division of the plane, appropriate for his chapter on crystallography; the record producer, in the idea of the "eternal cycle of life" that he sees in the print.

C. H. A. Broos

--

Escher considered it a joke that a biblical interpretation is usually given to the little book of "Job" in *Reptiles,* when actually it is only a packet of a Belgian brand of cigarette papers.

J. L. Locher

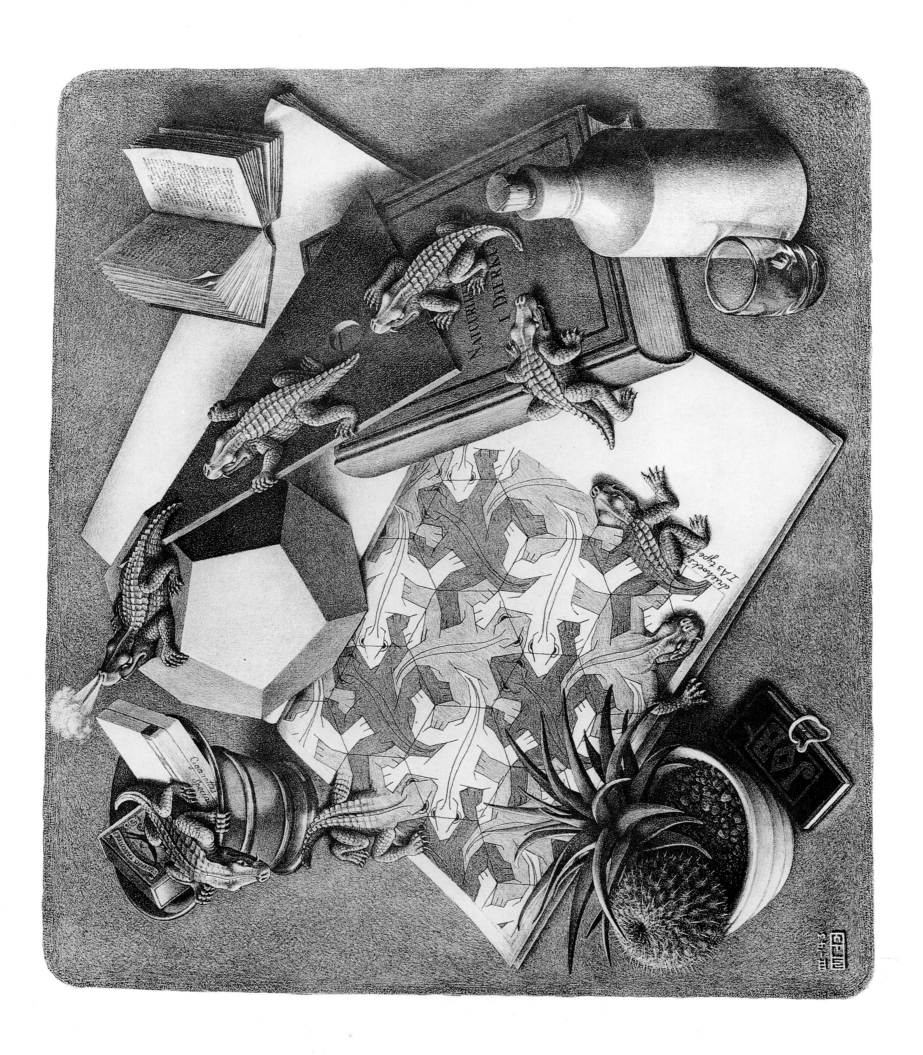

RELATIVITY

July 1953. Catalogue number 388
Woodcut
282 x 294 (11⅛ x 11⅝")
There are also copies colored by hand with colored pencil.

or scientists, the logical pictorial structure of Escher's prints, as well as the way in which he creates a connection between the visual phenomena, are the attractive aspects of his work. The other groups are less interested in the ingenious than in the mysterious and incomprehensible in Escher's prints. They are fascinated particularly by Escher's representation of imaginary spatial constructions, which can exist on paper but not in our everyday world, as, for example, in *Relativity, Other World,* or *House of Stairs.*

Escher's world is extraordinary but explicable; yet those who are susceptible to more irrational arguments prefer to speculate about its enigmatic qualities....

This attitude was the forerunner of a rage that led to an extraordinary popularity of Escher's prints in the world of hippies and Pop music. In the United States innumerable posters in Day-Glo colors—with titles such as *Atlantis (Double Planetoid)* and *Bad Trip (Dream)*—were manufactured after his work, which was also in demand for the decoration of record albums or T-shirts.

A hint of the reason for this popularity can be seen in these sentences by Thomas Albright...in *Rolling Stone,* in 1970: "...The main reason for the sudden run on Escher is the close parallel of his vision to the themes of contemporary 'psychedelic art'...[and] the fact that nothing is really as it seems and that everything is governed by higher laws of logic and mathematical laws that draw the universe and all its opposing elements together in a mysterious, unknowing harmony."

C. H. A. Broos

--

In this picture three gravitational forces operate perpendicularly to one another. Men are walking crisscross together on the floor and the stairs. Some of them, though belonging to different worlds, come very close together but can't be aware of each other's existence. Let us take some examples: In the center a fellow with a coal bag on his back comes up from a cellar. But the floor on which he sets his right foot is a wall for the seated man to his left, while to his right is another man coming downstairs, who lives in yet a third world. Another example: On the uppermost staircase, two persons are moving side by side, both of them from left to right. Yet one descends and the other ascends. M. C. E.

38

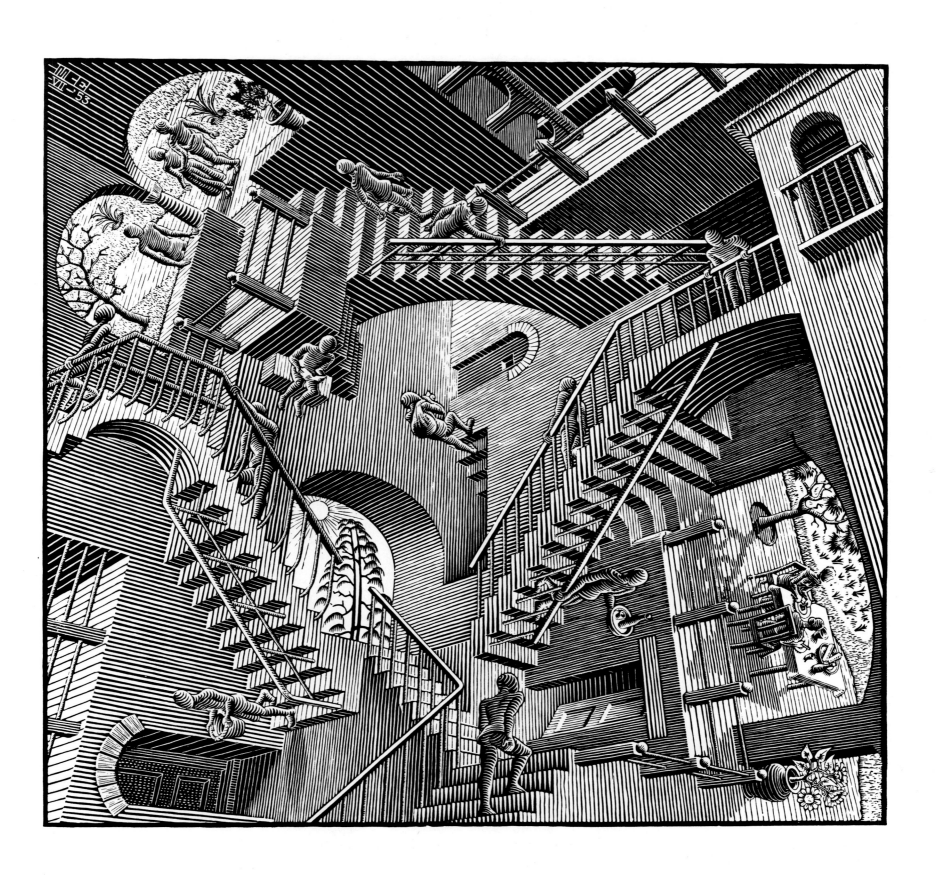

FISH
C. 1942
Woodcut on textile
Woodcuts printed exclusively on textiles have not been included in the Escher catalogue, hence this one was not assigned a catalogue number.

The fitting together of congruent figures whose shapes evoke in the observer an association with an object or a living creature intrigued me increasingly after that first Spanish visit in 1922. And although at the time I was mainly interested in free graphic art, I periodically returned to the mental gymnastics of my puzzles. In about 1924 I first printed a piece of fabric with a woodblock of a single animal motif that is repeated according to a particular system, always bearing in mind the principle that there may not be any "empty spaces"....I exhibited this piece of printed fabric together with my other work, but it was not successful. This is partly the reason why it was not until 1936, after I had visited the Alhambra a second time, that I spent a large part of my time puzzling with animal shapes.

I think I have never yet done any work with the aim of symbolizing a particular idea, but the fact that a symbol is sometimes discovered or remarked upon is valuable for me because it makes it easier to accept the inexplicable nature of my hobbies, which constantly preoccupy me.

The regular division of the plane into congruent figures evoking an association in the observer with a familiar natural object is one of these hobbies or problems....I have embarked on this geometric problem again and again over the years, trying to throw light on different aspects each time. I cannot imagine what my life would be like if this problem had never occurred to me; one might say that I am head over heels in love with it, and I still don't know why. M. C. E.

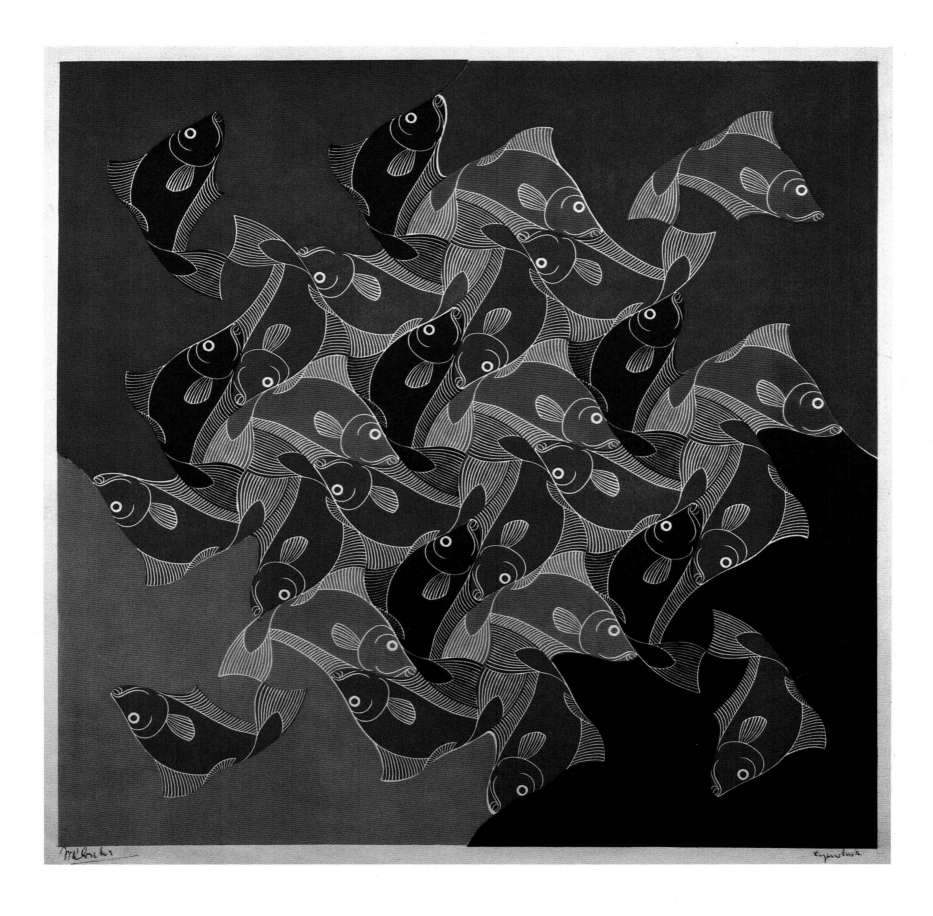

MÖBIUS STRIP II (RED ANTS)
February 1963. Catalogue number 441
Woodcut in red, black, and gray-green, printed from three blocks
453 x 205 (17⅞ x 8⅛")

The late professor G. H. Hardy once described "real mathematics" as having "a very high degree of *unexpectedness,* combined with *inevitability* and *economy*." These words describe equally well the work of M. C. Escher. As Escher said himself, "By keenly confronting the enigmas that surround us, and by analyzing the observations that I had made, I ended up in the domain of mathematics. Although I am absolutely innocent of training or knowledge in the exact sciences, I often seem to have more in common with mathematicians than with my fellow artists."

A fascinating introduction to elementary topology is provided by the two wood engravings *Möbius Strip I* and *Möbius Strip II.* The first Möbius strip has been cut down its entire length to illustrate the fact that it remains connected. The one-sidedness of the second strip is demonstrated by nine ants crawling along it; they are so lifelike that one can almost *feel* their little claws.
 H. S. M. Coxeter

- -

I have hardly ever experienced the pleasure of the artist who uses color for its own sake; I use color only when the nature of my shapes makes it necessary or when I am forced to do so by the fact that there are more than two motifs.
 M. C. E.

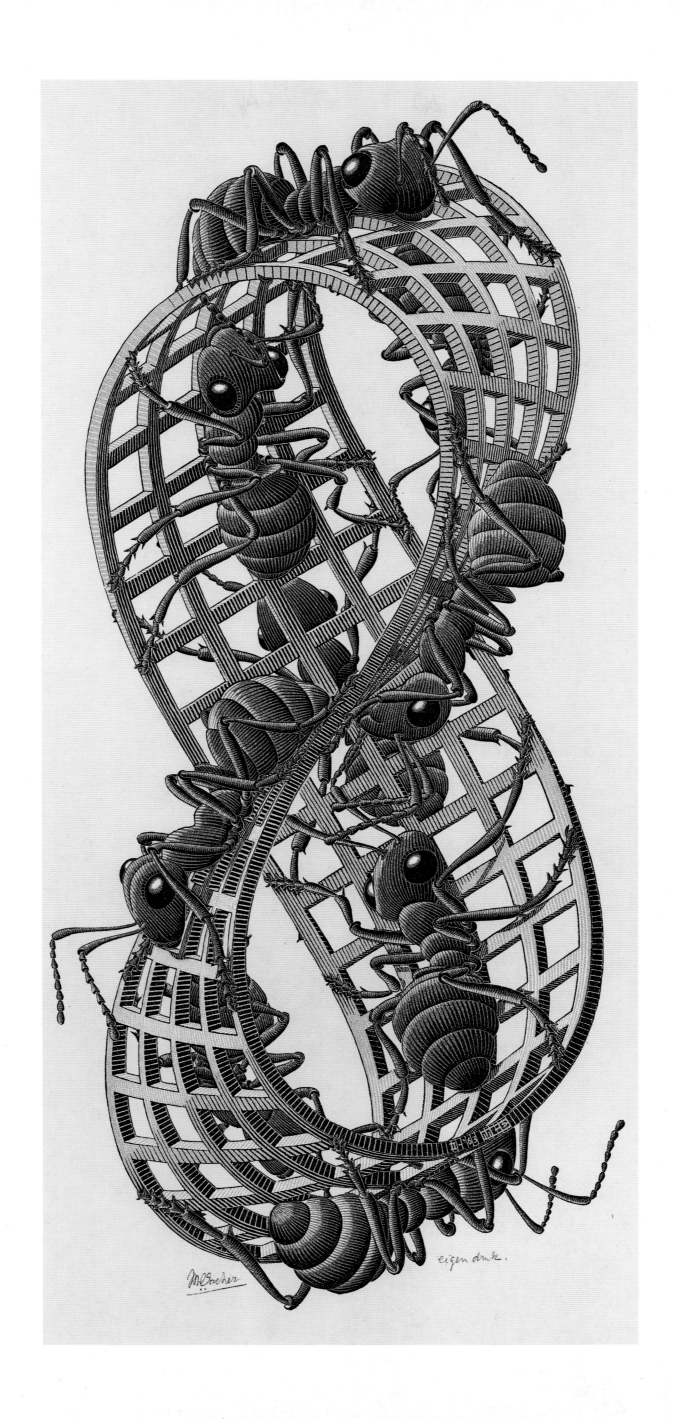

eigen druk.

SNAKES

July 1969. Catalogue number 448
Woodcut in orange, green, and black, printed from three blocks
498 x 447 (19⅝ x 17⅝")

I don't imagine that this will be a "masterpiece" (although we should really pretend to believe this of each new piece of work), but I'm extremely satisfied because my hand doesn't shake at all, and my eyes are still good enough for such precision work, thanks to a magnifying glass lit up by a circular neon tube (which doesn't heat the wood!). I've been doing this kind of work for over fifty years now, and nothing in this strange and frightening world seems more pleasant to me. What more could a person want? M. C. E.

--

In all the prints that he titled...*Limit* or *Path of Life,* Escher used his skill in the regular division of the plane to fill the print with similar, recognizable figures. In the print that concluded his work, the woodcut *Snakes* of 1969, he solved the problem of expressing the infinite in a yet more elegant way, even without using one of his regular division-of-the-plane patterns.

In the preliminary sketches, the scheme...can be seen on the outer edge of the circle. However, the center does not show the motif—the ring of a coat of chain mail—at its largest, but is again a limit of the print toward the infinitely small. The network for this tour de force is an invention of Escher's own, far more complicated than the one he used in the drawing after Coxeter. The three snakes that take the print from pure abstraction resulted from Escher's study of a number of photographs of snakes in books he bought for the purpose.

A striking feature of this print, which takes us to the limit of the infinite both at the edge and at the center, is that Escher made no attempt—as he had in previous works aimed at approaching the infinite—to depict the smallest circles visible to the naked eye. He felt that just the suggestion of an infinite decrease in size was sufficient.

Bruno Ernst

44

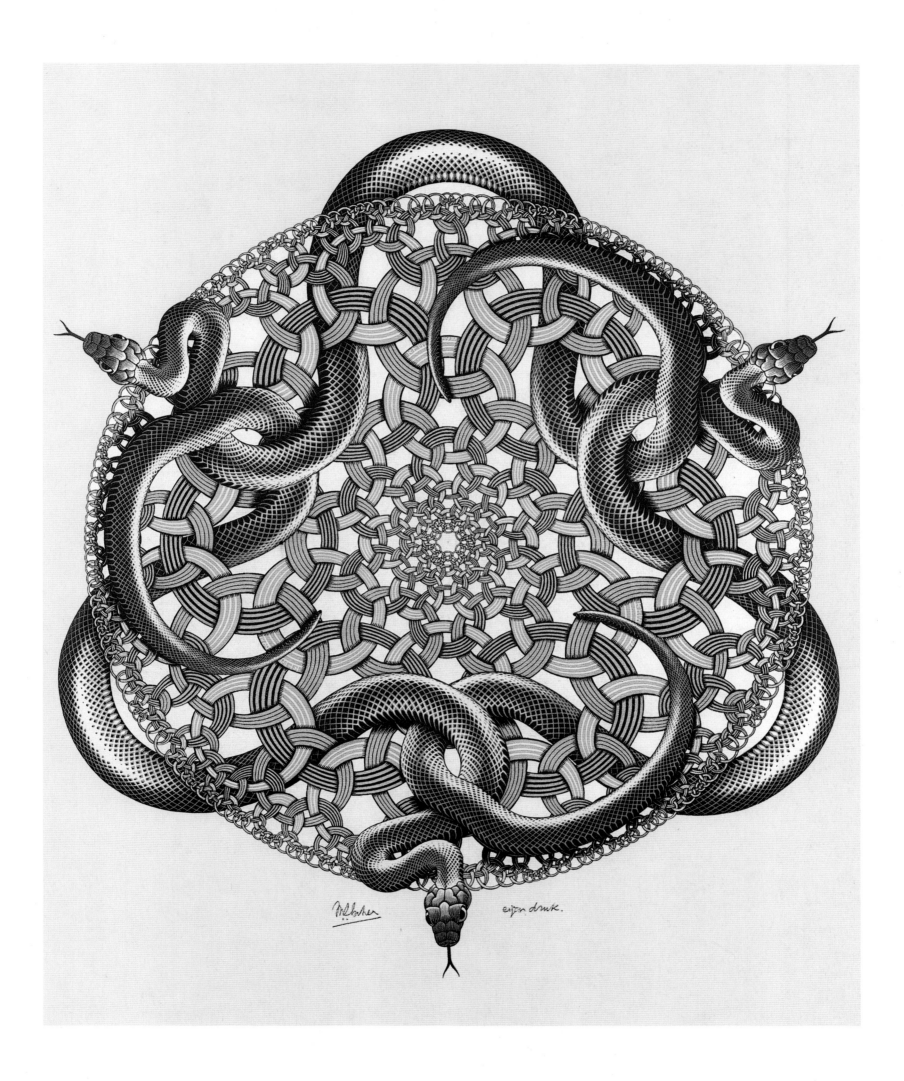

FISH
October 1941. Catalogue number 323
Woodcut in three tones of gray-green, printed from three blocks
507 x 384 (20 x 15⅛")

The method of printing used when no colors are included is generally to print from a block with black ink on white or off-white paper. I have serious objections to this method, even though I have used it myself for as long as I can remember. This is because of the inconsistency of the presence—even before we start—of one of the two contrasting elements, namely white, though we pretend to be creating both black *and* white. The latter is even continued in the margin of the sheet of paper. As a result, the balance between the two components of the contrast white *versus* black is disturbed. This is a nuisance in any print, but it becomes quite unacceptable in one concerned with the regular division of the plane. For here the white and the black portions are completely equal in value....It would be so much more logical, at least in theory, to print gray paper with both white and black ink. Unfortunately there are too many practical problems; not only are there technical difficulties in covering dark paper with a light ink, making it almost impossible to obtain a clear white, but in addition the whole procedure requires twice as much time and effort, because two blocks have to be cut intead of one—one for the white portions and one for the black....

Is it not feasible to accept "gray" not merely in a static sense...but also in a dynamic sense, as the origin of the contrast between white and black developing from it? In this way I consider the indeterminate, misty gray plane as a means of expressing static peace, of rendering the absence of time and the absence of dimension that preceded life and that will follow it; as a formless element into which all contrasts will dissolve again, "after death." M. C. E.

46

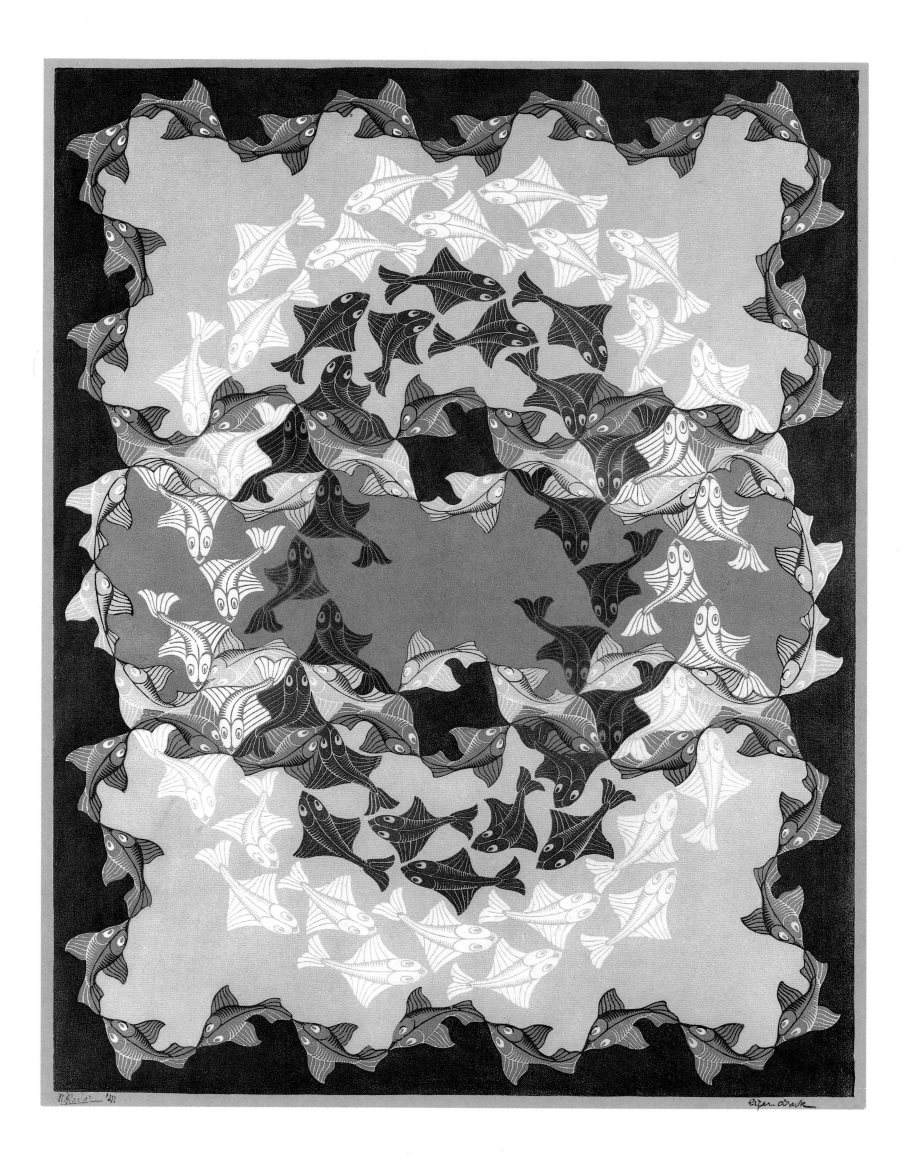

DRAWING HANDS

January 1948. Catalogue number 355
Lithograph
282 x 332 (11⅛ x 13⅛")

A sheet of paper is pinned upon a background with four thumbtacks. A right hand, holding a pencil, sketches a shirtcuff on the paper. It is only a rough sketch, but a little farther to the right a detailed drawing of a left hand emerges from the sleeve, rises from the plane, and comes to life. In its turn this left hand is sketching the cuff from which the right hand emerges.

Some years after I made this print, I saw exactly the same idea of two hands drawing each other in a book by the famous American cartoonist Saul Steinberg.

It was with a great deal of interest that I read the article on "left-handedness in drawing"....I was particularly struck by the suggestion that left-handed people might be more inclined to draw than to paint; in other words, that shape might be more important to them than color. As far as I'm concerned, this is perfectly true. I was exclusively left-handed from earliest childhood (at primary school I found learning to write with my right hand extremely difficult; I should probably have managed far more easily and naturally writing in mirror image with my left hand), and the fact that my feeling for shape is greater than that for color may also have resulted in my becoming a graphic artist rather than a painter. ...For a graphic artist who is always working with both an image and a mirror image, being ambidextrous is obviously a great advantage.

M. C. E.

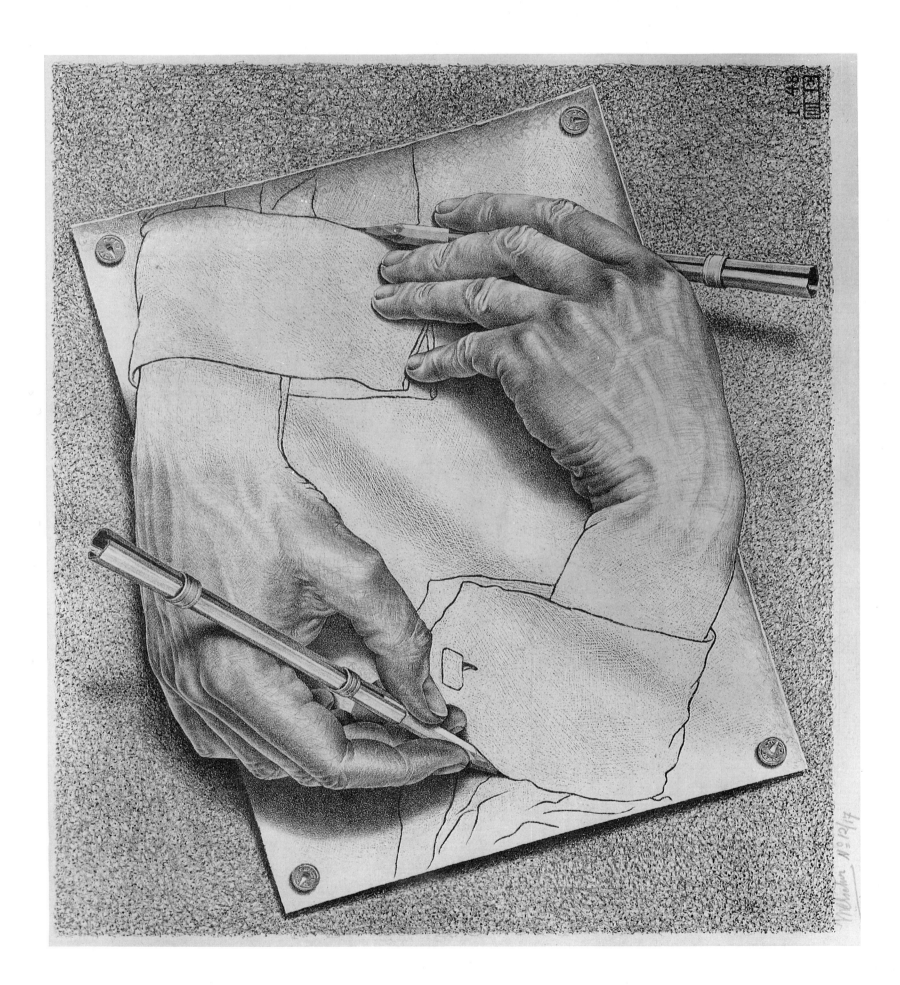

THREE SPHERES I
September 1945. Catalogue number 336
Wood engraving
279 x 169 (11 x 6⅝")

The attraction of many of Escher's prints lies in the fact that they suggest things that do not actually exist and sometimes even cannot exist. In contrast with the irrationality of the Surrealists, Escher's context is strictly rational; every illusion that is created is the result of a totally reasoned construction.

Every spatial picture on a plane is based on illusion. The surface used for the drawing is flat, two-dimensional; however, we perceive what is depicted as spatial, three-dimensional....

Escher was fascinated by the fact that the human brain absolutely insists on making two-dimensional pictures spatial. For some time he made playful attempts in his prints to "break through" this illusion of space; he seemed to be saying to the observer, "Look at it—it's flat and will always be flat!" In vain, as he himself realized full well. The illusion persists in spite of opposition....

In the woodcut *Three Spheres I*—which incidentally is a masterpiece of woodcutting skill— no spheres are depicted, but flat planes. The network of white ellipses suggests a spherical shape. In the top figure we see a frontal view of the flat plane; the three-dimensional suggestion is obvious here. The central figure has been cut from a sheet of drawing paper on which the top figure is shown, and then folded over. The fold should hinder the illusion of space; but no, we immediately turn it into a three-dimensional object. At the bottom Escher put another copy of the top figure, now lying "on the floor," but we refuse to believe this and see it as an elongated egg.

Bruno Ernst

50

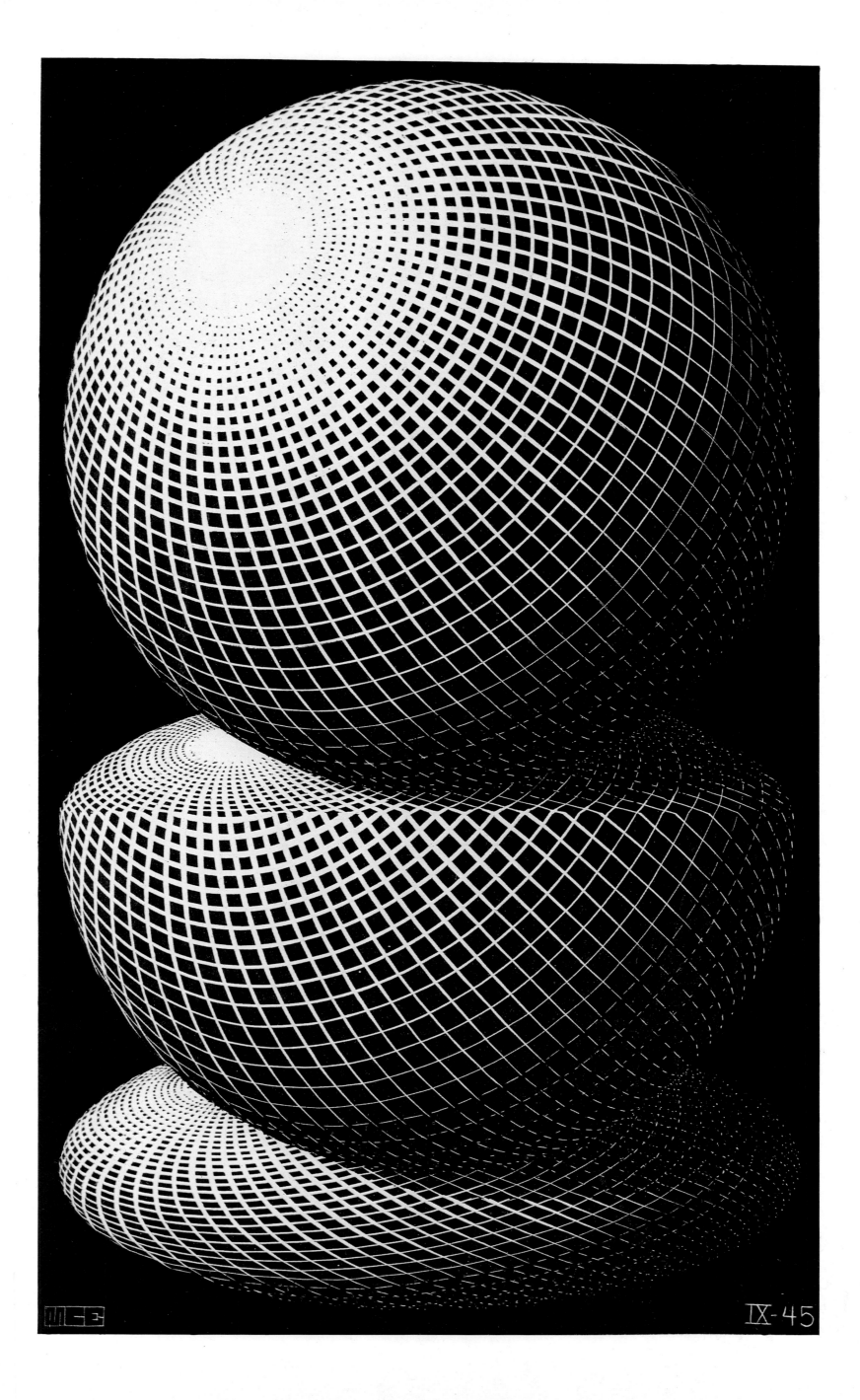

STARS

October 1948. Catalogue number 359
Wood engraving
320 x 260 (12⅝ x 10¼")
There are also copies colored by hand in watercolor as well as a version in black, blue, yellow, and pink, printed from four blocks. Of this version proofs exist printed from one or more blocks in various colors or color combinations.

All kinds of single, double, and triple polyhedrons are floating like stars through the air. In the center is a system of three regular octahedrons, a framework of beams. In this cage live two chameleons whose function is to add an element of life to this dead world. I chose them as inhabitants because their legs and tail are particularly well adapted to grasp the framework of their cage as it whirls through space.

--

There is no better opportunity of enjoying the starry sky in peace than on the pitch-black foredeck of a ship sailing through southern waters. In the balmy night you can stretch out on your back on a tarpaulin, and if you have a flashlight and a star map, you can quite leisurely fix the eternal figures of the constellations in your memory and identify them....

It has always irked me as improper that there are still so many people for whom the sky is no more than a mass of random points of light....It is quite possible for a layman in the field of astronomy like myself to enjoy recognizing all those noble, striking figures, which become all the more real as you get to know them better.

M. C. E.

52

WATERFALL
October 1961. Catalogue number 439
Lithograph
380 x 300 (15 x 11¾")
The "plants" at bottom left come from a 1942 drawing.

The water of a fall, which sets in motion a miller's wheel, zigzags gently down through a gutter between two towers till it reaches the point from which it drops down again. The miller can keep it in perpetual motion by adding a bucket of water now and then to compensate for evaporation.

The towers are equally high, yet the left one is a story higher than the other. The polyhedrons on their top have no special significance. I have put them there simply because I like them so much: to the left, three intersecting cubes, to the right, three octahedrons.

The background is a southern Italian terraced landscape, and the lower left corner is filled with greatly enlarged moss plants. The cups are, in reality, only about a tenth of an inch high.

The theme of this self-supporting waterfall is based upon the triangle...of Roger Penrose, a son of the inventor of the "continuous staircase" in *Ascending and Descending*. It is perhaps worthwhile to quote his article in *The British Journal of Psychology*, February 1958: "Here is a perspective drawing, each part of which is accepted as representing a three-dimensional, rectangular structure. The lines of the drawing are, however, connected in such a manner as to reproduce an impossibility. As the eye pursues the lines of the figure, sudden changes in the interpretation of distance of the object from the observer are necessary." M. C. E.

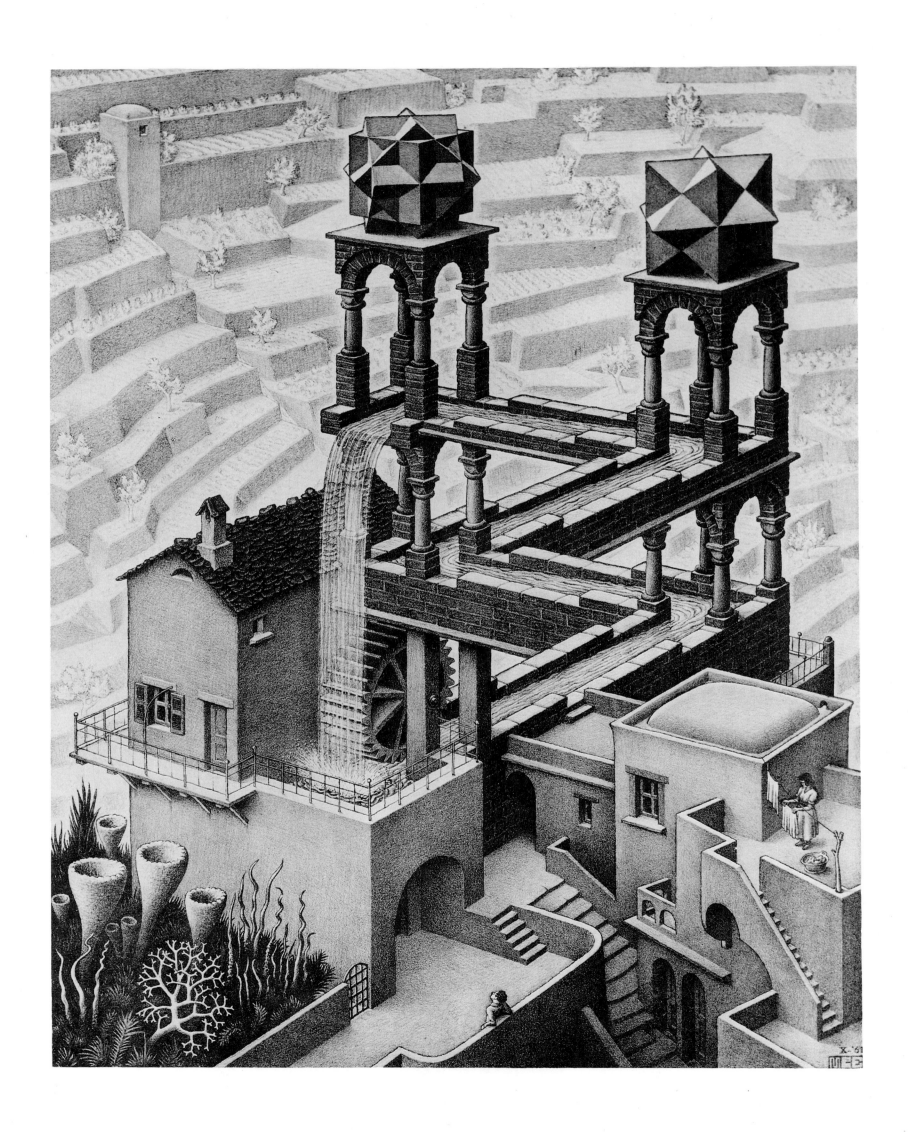

DOUBLE PLANETOID (DOUBLE PLANET)

December 1949. Catalogue number 365
Wood engraving in green, dark blue, black, and white,
printed from four blocks; second state
Diameter 374 (14¾")
There exist proofs in other color combinations and in
black only. One copy was mounted by Escher as a ro-
tating disk.

Two regular tetrahedrons, piercing each other, float through space as a planetoid. The light-colored one is inhabited by human beings who have completely transformed their region into a complex of houses, bridges, and roads. The darker tetrahedron has remained in its natural state, with rocks on which plants and prehistoric animals live. The two bodies fit together to make a whole, but they have no knowledge of each other.

--

If we create a universe, let it not be abstract or vague but rather let it concretely represent recognizable things. Let us construct a two-dimensional universe out of an infinitely large number of identical but distinctly recognizable components. It could be a universe of stones, stars, plants, animals, or people. M. C. E.

--

Like Leonardo da Vinci and Albrecht Dürer, Escher had a strong appreciation of the five Platonic solids: the regular tetrahedron, octahedron, cube, icosahedron, and dodecahedron. "They symbolize," he said, "man's longing for harmony and order, but at the same time their perfection awes us with a sense of our own helplessness. Regular polyhedra are not inventions of the human mind, for they existed long before mankind appeared on the scene." H. S. M. Coxeter

DREAM (MANTIS RELIGIOSA)

April 1935. Catalogue number 272
Wood engraving
322 x 241 (12⅝ x 9½")

Dream is an example of another way of linking different facets of reality, one that Escher used several times....Although the subject as a whole is entirely imaginary, this print is built up of elements that each derive from real observations. Separate observations are combined into a whole *(Study of Praying Mantis, Santa Maria dell'Ospedale, Ravello,* and *Study of a Bishop's Tomb).* For Escher, two different forms of reality also coincide in the interpretation of this print. Its meaning is ambiguous: is the bishop dreaming of a praying mantis, or is the entire picture the dream of its creator?...*Dream*...show[s] an extravagant world. [Its] bizarre content has, in addition, a distinctly humorous cast. Humor is expressed in the...somewhat derisive combination of the two widely divergent forms of prayer in *Dream*—the prayer of the statue of the dead bishop and the prayerful attitude of the mantis....

One of the important aspects of the print *Dream* is Escher's experimentation with the technical problem of achieving a gradual transition from light to dark in a woodcut or wood engraving. Here, gray is not an unstructured mixture of black and white but a series of black-and-white lines. A light area consists of thin black lines alternating with wider white ones. By a gradual widening of the black lines and narrowing of the white ones, the area becomes darker. In *Dream* the rendition of the vaulting offered an especially good opportunity to experiment with this transition from light to dark....

In looking back on his work before 1937, Escher himself was inclined to emphasize experimentation with graphic mediums and to consider most of the works of this period no more than exercises; but we also can recognize in this work a keen observation of the world around him as well as the expression of his own fantasies.

J. L. Locher

58

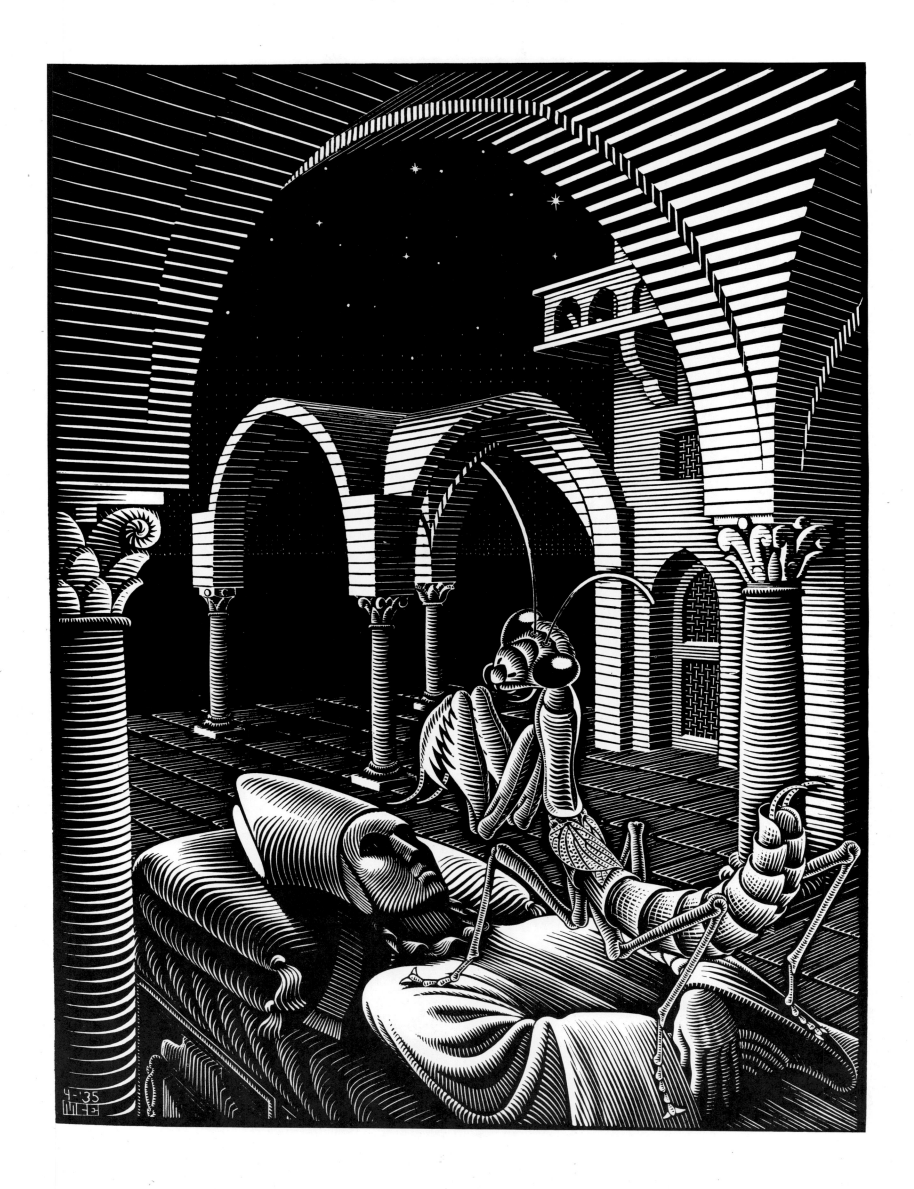

CONCENTRIC RINDS (CONCENTRIC SPACE FILLING/REGULAR SPHERE DIVISION)
May 1953. Catalogue number 387
Wood engraving
241 x 241 (9½ x 9½")
There are also copies colored by hand with watercolor.

Four spherical concentric rinds are illuminated by a central source of light. Each rind consists of a network of nine large circles, which divide the surface of the sphere into forty-eight similar-shaped spherical triangles.

--

[The regular division of the plane] is not my only hobby; there are a few others that intrigue me and sometimes lead me away from the plane and into space. Awareness of the three dimensions, the notion of plasticity, is not as general as one might expect in spatial creatures like ourselves. An understanding of the relationships between plane and space is a source of emotion for me; and emotion is a strong incentive, or at least a stimulus for making a picture.

It is quite true that "we know only a part," we know only a minute part. M. C. E.

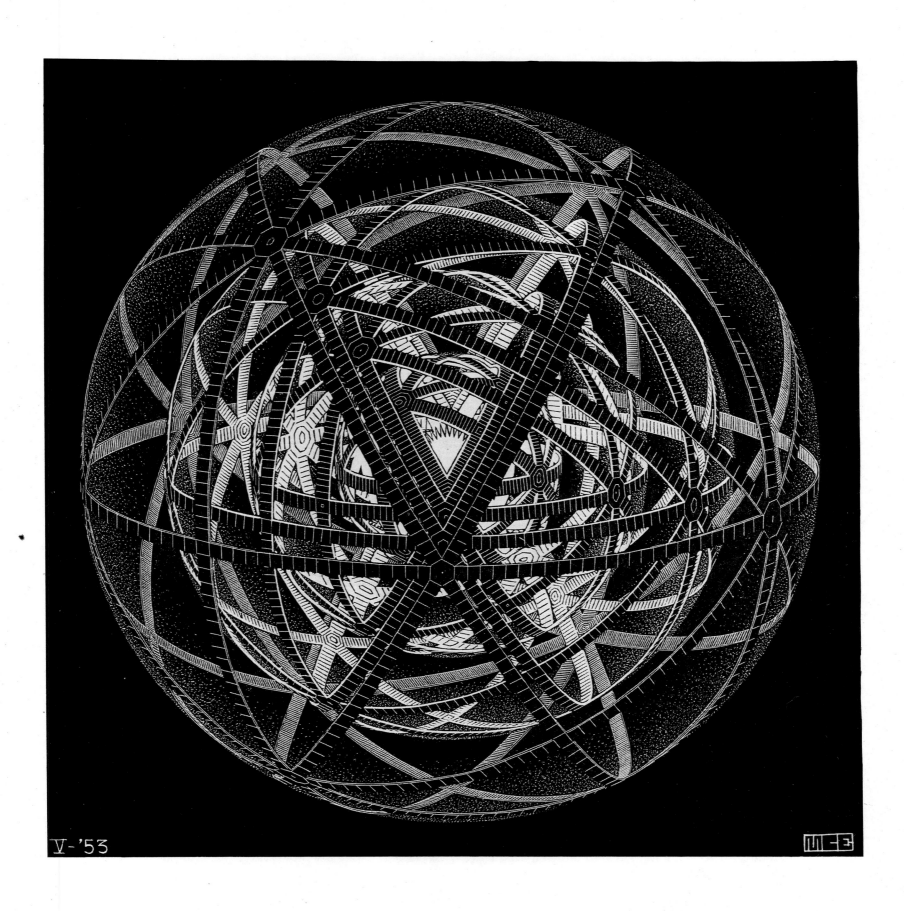

V-'53

DRAGON

March 1952. Catalogue number 379
Wood engraving
321 x 241 (12⅝ x 9½")
There exists a proof printed from a similar block, which
Escher himself considered a failure.

A nother ambiguity—a more or less absurd dragon. It *pretends* to be spatial, but it *is* flat, and you can cut two incisions in it and fold it to obtain two holes. Then, pretending that it is three-dimensional, the dragon obstinately slips its head through one opening and its tail through the other.

--

If someone has expressed himself in graphics from his youth; if he has created visual images for many years, always using such graphic means as woodblocks, copper plates, and lithographic stones, as well as press, ink, and all sorts of paper for printing on, this technique finally becomes second nature to him. Obviously the technique itself must have been the most important thing for him, at least at the beginning of his career as graphic artist, or he would not have specialized in that direction. In addition, he must continue to use the specific medium he has chosen with unflagging enthusiasm throughout the years, and he will undoubtedly strive all his life for a technical expertise that he will never completely acquire.

Meanwhile, all this technique is merely a means, not an end in itself. The end he strives for is something else than a perfectly executed print. His aim is to depict dreams, ideas, or problems in such a way that other people can observe and consider them. The illusion that an artist wishes to create is much more subjective and far more important than the objective, physical means with which he tries to create it. It is [a] very personal matter. M. C. E.

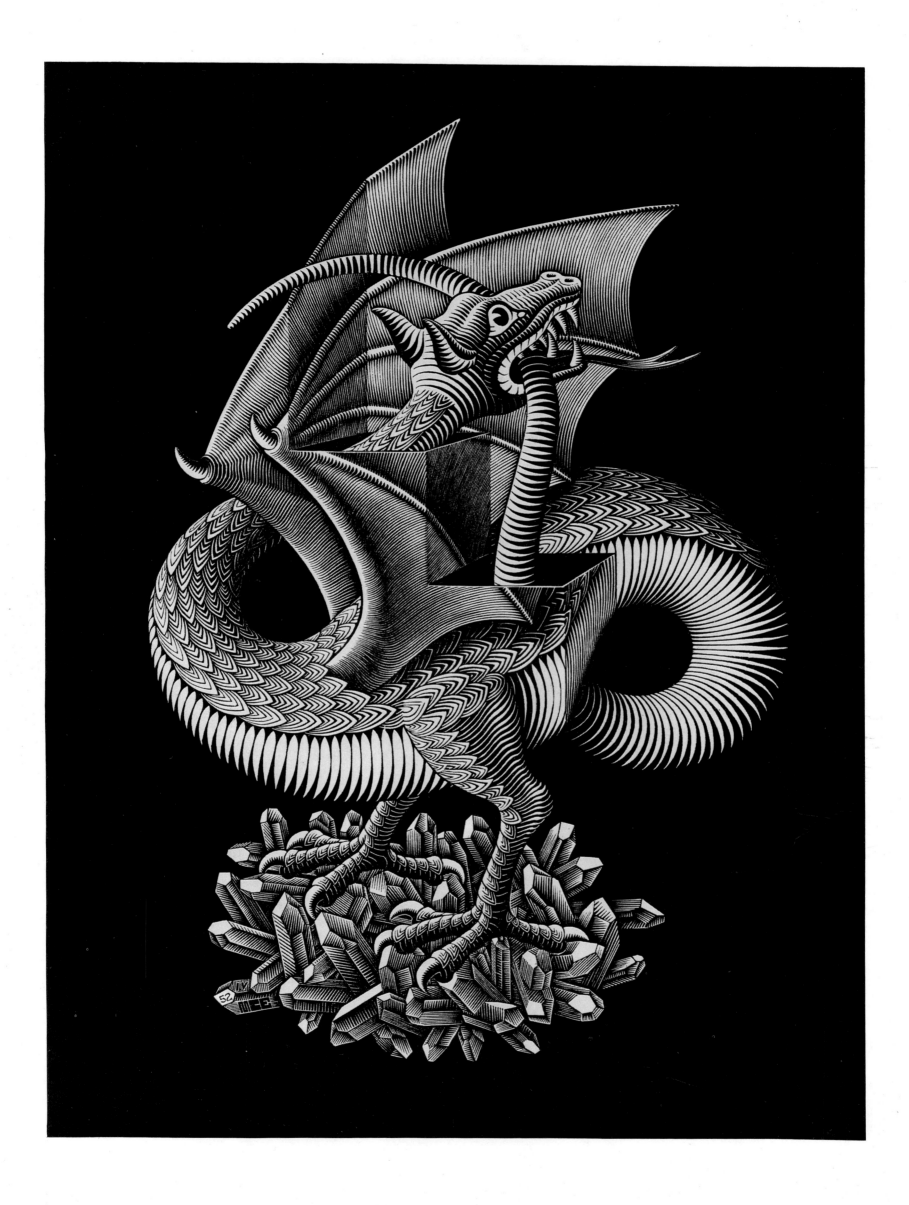